Komar & Melamid, Untitled, from the series *Bayonne*, 1990.
Cover: Mike and Doug Starn, detail of *Take Off Your Skin*, 1990-94.
Back cover: Photographer unknown, spirit photograph, ca. 1870. Private collection.

see

DAVID **BONETTI**	GUSTAVUS **KUNDAHL**
ALBERT **CHONG**	DINH Q. **LE**
NICOLE **COOLEY**	GAVIN **LEE**
HARRY **CROSBY**	CHARLES **MALONE**
JAMES **CRUMP**	SALLY **MANN**
LUKAS **FELZMANN**	MARÍA **MARTÍNEZ-CAÑAS**
NAN **GOLDIN**	RUBÉN **ORTÍZ TORRES**
TAISHI **HIROKAWA**	REBECCA **SOLNIT**
YOUNG **KIM**	MIKE AND DOUG **STARN**
KOMAR & **MELAMID**	YOSUKE **YAMAHATA**

The Friends of Photography, San Francisco

see: a journal of visual culture

Editor in Chief
Andy Grundberg

Editor
Michael Read

Associate Editor
Steven Jenkins

Design
Toki Design

Editorial Board
Annie Barrows Marvin Heiferman
May Castleberry Howard Junker
Merry Foresta Carole Kismaric
Jonathan Galassi Constance Sullivan

Advertising Coordinator
Charlene Rule

Subscriptions Manager
Heather Tissue

Editorial Assistants
Denyse Jones Grace Loh
Gustavus Kundahl Charlene Rule

The Friends of Photography
Andy Grundberg, Director
Deborah Klochko, Deputy Director for Public Programs
Barbara Alvarez, Director of Development and Marketing
Lisa Robb, Director of Operations and Administration

Public Programs
Julia Brashares Steven Jenkins
Joanne Chan Michael Read
Elizabeth Dranitzke Charlene Rule

Marketing and Development
Carrie Mahan Heather Tissue

Administration
Pam Allen Winona Reyes
David Bebb Erika Vollmar
Betsy Pauley

The Friends of Photography Bookstore
Charles Hartman, Manager
Sharon Collins
Sarah Kremer

see is published by
The Friends of Photography

ISSN 1076-4550, ISBN 0-262-56089-5

see is a benefit of membership in The Friends of Photogra-
phy, a national nonprofit organization that serves as a forum
for the intersection of images and ideas, promoting visual
literacy through programs of exhibitions, education, publica-
tions and awards. Membership is open to all; for informa-
tion, write Membership, The Friends of Photography, 250
Fourth Street, San Francisco CA 94103, or call 415.495.7000.

see also is distributed worldwide by MIT Press, Cambridge,
Massachusetts and London, England.

The publication of **see** is made possible with the support
of the Andy Warhol Foundation for the Visual Arts, the Cali-
fornia Arts Council, Grants for the Arts of the City of San
Francisco, and the members of The Friends of Photography.

Second class postage paid at San Francisco, CA, and
additional mailing offices.
Printed in Hong Kong by C & C Offset Printing Co., Ltd.

Editorial and advertising address:
250 Fourth Street
San Francisco CA 94103
phone: 415.495.7000
fax: 415.495.8517
E-mail: SEEfop@aol.com

CONTENTS

The Friends of Photography

seen

One particularly camera-induced problem contemporary artists face is finding a subject matter that they can legitimately claim as their own. The problem isn't just that photographers of the last 150 years have covered the world, Sherwin-Williams style, with their images; it's that there is so little left in the way of a boundary between individual and mass-produced representation. → Not surprisingly, in our postmodern world, representation has become a subject in and of itself. This, at least, is one way to look at Sally Mann's recent color pictures of her children, which include intriguing clues about the antecedents of their poses. Art and popular culture are equally implicated in the theater of physical pleasure that the children, and the photographer, collaboratively create. These are, in short, noticeably self-reflexive photographs. (Mann was named Photographer of the Year in the 1995 Peer Awards balloting conducted by The Friends of Photography, and now appears in see for the first time.) → Mike and Doug Starns' contribution to this issue's *Open Space* pages is similarly self-aware. Designed specifically for the page, their work reflects both on the ontology of photography (the sun) and on a pre-photographic history of representation (the portrait). Similarly, Lukas Felzmann's images limn not only landscapes but also a history of how knowledge is stored and transferred through images. → This urge to acknowledge the hold that visual images have on our perception, understanding and memory extends to the work in this issue's *Tracing Cultures* portfolio, which also is a reflection of how photography can be used to examine one's cultural origins and identity. As Rebecca Solnit's essay makes clear, photographs, like memory, are slippery containers of truth—or, perhaps more simply, containers of different varieties of truths. This, too, is one message of David Bonetti's memoire occasioned by the photographs Nan Goldin took in Boston at a time when Bonetti, now the art critic of the *San Francisco Examiner*, was an outsider looking enviously in at a world of glamour and rebellion. Its representation, since consigned to golden-oldie status, looks even more beautiful with age. → Is this a sign that reflexivity is the hallmark of today's visual world? Not necessarily any more than it was in the past. As Harry Crosby noted some seventy years ago, the Japanese emblem of the sun goddess was a mirror.
—Andy Grundberg

Media watch

The metamorphosis of a shooter

Legend has it that the original script for *Dirty Harry*, Clint Eastwood's most famous movie, was based on the trials and tribulations of a Detroit-based photographer named Harry Callahan. The gripping plot revolved around young Callahan as he struggled, in the name of art, to rise above the confining camera-club tradition. By the first rewrite, the story goes, the script doctors had slipped a .357 Magnum into Callahan's camera bag. By the second draft they had changed his profession from photographer to rogue cop, and moved the action from Michigan to the mean streets of San Francisco. They didn't feel the need to tinker with the character's name, however—Harry Callahan, with its aura of gruff manliness, was retained throughout the *Dirty Harry* series.

Perhaps Eastwood, now long in the tooth, was eager to finally portray a true blue photographer when he signed on as director and star of *The Bridges of Madison County*. This recent film, and the inexplicably popular book on which it is based, paints as vivid a picture of sensitive photographers as *Dirty Harry* did of vengeful cops. In *Bridges,* homicidal maniacs are replaced by lonely housewife Meryl Streep as the target of Eastwood's

loose cannon. And (luckily for Streep) the cannon itself has been transformed from a black, automatic pistol into a battle-weathered old Nikon (still black, of course). But make no mistake: Eastwood's new tool is just as surely an extension of his formidable manhood, and his character is as trigger-happy as ever. The way he waves that camera around conjures up images of a tofu-crazed photographic bounty hunter (*Bridges'* Robert Kincaid is, naturally, a vegetarian). As the lonely housewife's son remarks, "Some damn perverted photographic mind thought *that* up."

All of this begs the question: What does Hollywood have in store for us in regards to future dramatizations of photographers? Will Al Gore discover his true calling by taking the starring role in an Edward Weston biopic? Will Sylvester Stallone star as Robert Capa? Sandra Bernhardt as Tina Modotti? John Travolta as Robert Mapplethorpe? Keanu Reeves as the young Ansel Adams? Nick Nolte as Alfred Stieglitz? We shutter to think.
—Michael Read

Dirty Harry: © 1971 Warner Bros, Inc. and The Malpaso Company.
The Bridges of Madison County: © 1995 Warner Bros., a division of Time Warner Entertainment Company, L.P.

Snapshots from our recent trip to Hong Kong

Photographs by Michael Read.

Richard Nixon

Richard Nixon

Philatelist's corner

Another in a line of "new Nixons" has risen, Phoenix-like, out of the ashes of presumed defeat—this time in the form of the Richard M. Nixon 32-cent commemorative stamp. Designed by New York City artist Daniel Schwartz and unveiled by Nixon's daughters, Tricia and Julie, in April at the Richard Nixon Library and Birthplace in Yorba Linda, California, the stamp, like much associated with our 37th president, provokes in those who lived through his presidency a sense of cognitive dissonance bordering on nausea.

The stamp manages to combine the glow of youth (one can almost imagine the former president's index finger pointing out from under the perforated frame of the stamp, as if to accuse one last Red of something un-American) with the aura of power, qualities that rarely coexisted during Nixon's five years and seven months in office. One can't help but notice that he poses without a five-o'clock shadow and without a trace of perspiration. The unfinished quality of the painting leaves Nixon's American flag lapel pin to the imagination, perhaps in homage to Gilbert Stuart's unfinished portrait of George Washington.

For some reason the stamp, of which 80 million copies were printed, has proved unpopular with post-office customers.

—Robert Firpo-Cappiello

a year after the introduction of dry plate photography. —Letter to the Editor, *New York Times*, 1884.

Timeless photographs

Being media junkies, and wanting to take the pulse of America, we rushed to buy *Time* and *Newsweek* the week immediately following the Oklahoma City bombing last April. *Time*'s cover portrayed "The Face of Terror": a portrait of blond, clean-cut Timothy McVeigh, otherwise known as John Doe #1. The shocker was that this "face of terror" looked like a nice Boy Scout from down the street, and not the Iranian-looking suspects first reported to be on the lam.

In a small inset photo on the cover, *Time* showed a photo of a firefighter cradling a badly burned infant that the world has come to know as Baylee Almon. This image is more graphically horrific than the large photo of McVeigh, which is perhaps why *Newsweek* chose to run it as *its* cover (although close inspection reveals them to be two different photographs). The horror and drama presented by this image—a baby so badly burned, the desperation of the firefighter, and possibly the hope he felt as he tried to revive the little girl—resonated within all who hoped for the best but feared the worst. And the worst was true in this case. The child died shortly after the photo was taken.

Now there is talk of erecting a statue based on the photograph of Baylee Almon, in the tradition of the famous statue based on Joe Rosenthal's picture of Marines raising the flag at Iwo Jima. Which brings to mind another photo taken fifty-odd years ago: W. Eugene Smith's image of an American soldier on Saipan with a dying infant in his arms. Like the shot from Oklahoma City, this one shows a grown man in uniform, large and powerful, sheltering a baby with an almost maternal tenderness. Both images are similar in composition, even though Smith was a trained pro and the Oklahoma City photographer a lucky amateur. In the face of tragedy, the distinction doesn't matter.

—Amy Howorth

Time, May 1, 1995.

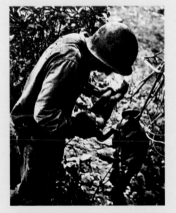

W. Eugene Smith, *Saipan*, 1944.

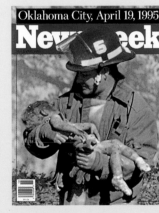

Newsweek, May 1, 1995.

Photography affords a very nice pastime to certain people, but the multiplication of instantaneous cameras has become a perfect nuisance to the general public.
—Letter to the Editor,
The Daily News, 1895.

Infants under the age of twenty-one, free-lance journalists, certified lunatics, American tourists and Smart Set hangers-on, shall in no case be permitted to take photographs.
—"Regulations for Camera-Fiends,"
Punch, 1906.

Photography as a fad is well-nigh on its last legs, thanks principally to the bicycle craze.
—Alfred Stieglitz, 1897.

perspectives

COMPILED BY DEBORAH KLOCHKO

Some early photographs were known as "mirrors with a memory." People had their photograph taken with the spirits of their dearly departed. There was a time when the only photograph of some people was taken after they had died. Some photographers took on the role of undertaker in dressing and arranging the deceased.

During the mid-nineteenth century, it was believed that photographing the retina of a recently deceased person—a practice known as **optography**—would reveal the last image that person had seen before dying. Policemen were especially interested in this supposed phenomenon, particularly when attempting to solve murder cases.

I would rather have such a memorial of one I dearly loved, than the noblest artist's work ever produced.
—Elizabeth Barrett

EVEN BEFORE THE INTRODUCTION of photography, death had a rich and commonly recognized visual vocabulary, much of which was utilized in postmortem images. Popular motifs in death images included willow trees, mourners turned away from the viewer, urns, angels, sun, gates, the arches and broken columns.

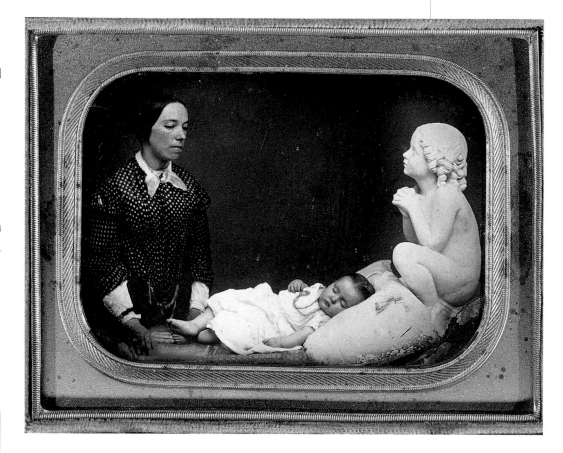

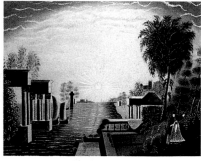

the weeping willow = sorrow
urns = death of an adult
sun = glorified souls
gates = passageway to heaven
arches = the house of the dead
eye = divine wisdom

PHOTOGRAPHY, DEATH

Ars moriendi

WHILE CONTEMPORARY WESTERN SOCIETY considers death an uncomfortable topic of discussion, nineteenth-century attitudes toward dying, death and mourning were both more practical and ritual-ized, and can be traced to the Middle Ages. *Ars moriendi*, **the art of dying well,** dictated the proper way of progressing through the final stages of life. The rules of death were more specific, concerning everything from proper attire for the bereaved and length of mourning to how death was represented visually.

Postmortem Photography

In the early years of photography, postmortem images often were the only existing photographic representations of the deceased. Postmortem photography was widely practiced in Europe and America, and was a common service provided by professional portrait photographers who would prepare, dress, pose and photograph the deceased in one visit. Fellow photographers often shared professional tips on arranging bodies.

Gone but not forgotten.—epitaph

Originating in America in 1841, Spiritualism quickly was embraced both in this country and in Europe. Within a decade of its introduction, there were two million followers in the United States alone. **Spiritualists believed in a life after death in which spirits of the departed could communicate with the living.** This communication usually was through mediums and often was in the form of rappings, knocking or the moving of objects.

Soon spirit photographers were offering images of sitters posed with their departed loved ones at much higher prices than a traditional photograph. The spirits were not seen at the time the photograph was taken, but nebulous spirit forms appeared in the finished print. **While many of the photographers were eventually exposed as frauds, there were a few who could not be found guilty of any trickery.**

When a photograph of a

spirit was taken in 1861

by William Mumler, the

Memento Mori—

movement had its first

Latin for

visual documentation of

"remember

this communication from

thy death"

the other side.

AND THE
GREAT BEYOND

Sir Arthur Conan Doyle, creator of Sherlock Holmes, was a confirmed Spiritualist. His belief in communication with "the great beyond" led him to support research and write books on the subject.

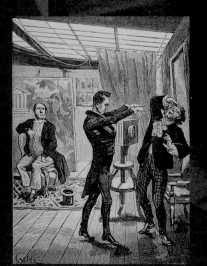

Special thanks to Dan Meinwald for providing advice, ideas and inspiration and to Robert Shimshak for sharing his collection.

New Books on **Photography** from

THE J. PAUL GETTY MUSEUM

In Focus

An exciting new series of small-format books that contain generous selections of works by major photographers from the Museum's collection. In addition to 50 duotone reproductions with brief, informative accompanying texts, each volume contains excerpts from a colloquium in which leading experts discuss the photographer's career, and a chronology of the photographer's life.

Now available: André Kertész, László Moholy-Nagy, and Alfred Stieglitz

"The editing, writing, design, and production are all superb," wrote John T. Hill about the first In Focus volume. And Russell Hart called the Kertész volume "a little gem of a book."

Each volume:
50 duotone illustrations
approximately 144 pages, 6 x 7 1/2 inches
Paper, $15.95

Walker Evans:
The Getty Museum Collection
Judith Keller

This lavishly illustrated volume brings together all of the Getty Museum's holdings of Walker Evans material, including some 1200 images from all phases of Evans's long and influential career.

Judith Keller is Associate Curator of Photographs at the J. Paul Getty Museum.

1138 duotone and 31 color illustrations
416 pages, 9 7/16 x 11 inches
Cloth, $95.00

The J. Paul Getty Museum:
Handbook of the Photographs Collection
Weston Naef

Since it began collecting photographs in 1984, the Getty Museum has formed one of the great photography collections in the world. In this beautiful volume, Curator Weston Naef has selected more than two hundred of the Museum's masterpieces and written brief commentaries on each. Julia Margaret Cameron, Alfred Stieglitz, Imogen Cunningham, Eugène Atget, and Diane Arbus are among the more than one hundred photographers whose work is reproduced. Also included is an index of photographers whose work is represented in the Getty Museum.

Weston Naef is Curator of Photographs at the J. Paul Getty Museum.

256 pages, 5 1/2 x 9 1/2 inches
150 duotone and 56 color illustrations
Paper, $12.95

Fine 19th and 20th Century photographs

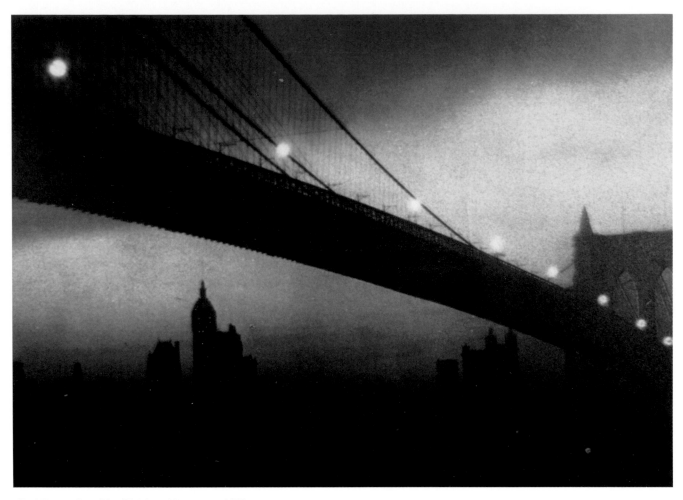

Karl Struss, Brooklyn Bridge, Nocturne 1912
Vintage Gum Platinum Print, 10" x 12 3/4"

19th Century

Eugene Atget . Edouard Baldus . Louis De Clercq .
Julia Margaret Cameron . Eugene Cuvelier . Roger
Fenton . Gustave Le Gray . Eadweard Muybridge .
William Henry Fox Talbot . Felix Teynard . Linnaeus
Tripe . Carleton Watkins

20th Century

Ansel Adams . Bill Brandt . Linda Butler . Imogen
Cunningham . Rod Dresser . Ralph Gibson . Yousuf Karsh .
André Kertész . Michael Kenna . Akira Kitajima . Robert
Mapplethorpe . Olivia Parker . Irving Penn . Tomio Seike .
Andres Serrano . Paul Strand . Edward Weston

Representative for the Estate of André Kertész
Exclusive agent for the Ansel Adams Museum Set

THE WESTON GALLERY
P.O. Box 655, Carmel, CA 93921

Sixth Avenue near Lincoln
(408) 624-4453 Fax (408) 624-7190

Dinh Q. Le, *Self Portrait After Bosch, "The Temptation
of St. Anthony,"* 1991.

IN A SOCIETY TRANSFIXED BY ANXIETY about its own changing demographics, words like "multiculturalism" and "immigration" have taken on politicized, reductive meanings. But well beyond the territory of sloganeering and demagoguery, many younger artists are providing complex visual evidence of what it means to live across and between cultures. The work reproduced in this portfolio comes from artists who have experienced, firsthand or by inheritance, the simultaneously acute and chronic sense of rupture, dislocation, adjustment and loss that comes from coming from somewhere else.

The reason that artists today are concentrating on the terms of their cultural identity and status within the larger culture of the United States is not difficult to discern. No longer does the picture of a society made up of European descendants and "others" describe with any accuracy the texture of our increasingly diverse national makeup (if, in fact, it ever did). Indeed, "otherness" merely is a construction created by those seeking to form (or, more recently, to shore up) a simple, coherent version of our national identity. The reason that photographs play a key role in the work of many of these artists seems equally obvious: camera images are tokens of people, times and places that cannot be recaptured except in terms of the photographic image. Most of these photographs are mementos of the existence of an earlier generation and, in some cases, evidence of the changes that have made the past irretrievable.

Photography often has been called a "universal language," capable of transcending differences of language and of culture. Like anthropology and ethnography, it was thought to have its roots in a scientific, empirical point of view that gave it universal credence. But photography's claim to represent other cultures impartially and fairly is no more accepted today than that of the social sciences; the notion of observation and description outside of culture has been discredited in both theory and practice. This perhaps explains why the artists of *Tracing Cultures* insist on contextualizing the photographic image by fragmenting it, displacing it and juxtaposing it with texts, paint, wood, metal and other materials. Theirs is a photography in which subjectivity has replaced subjecthood, and in which the power of representation rests, ultimately, with those who are represented. – —Andy Grundberg

Tracing Cultures is one of three exhibitions that comprise *Points of Entry*, a collaborative series organized by the Museum of Photographic Arts, the Center for Creative Photography and The Friends of Photography.

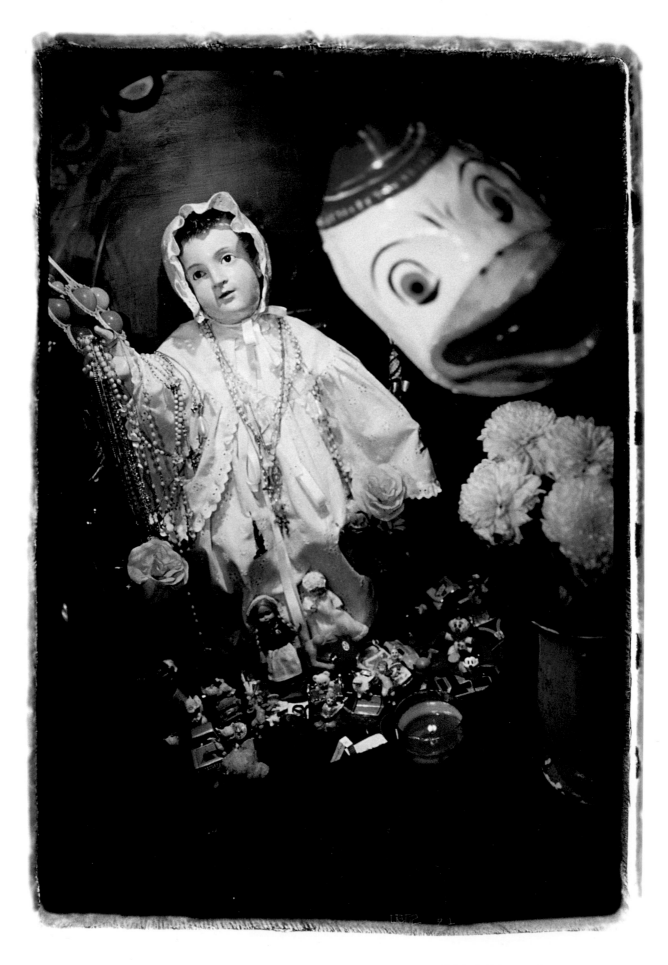

Rubén Ortíz Torres, *Santo Niño/Holy Kid,*
Guanajuato, Mexico, 1991.

see **12**

Winnifred Lynn was 80 years old on Oct 30th 1994. Aunt Maudie told her that she was born in 1914 in Vere Clarendon She was born first then her twin brother was born & died soon after. "your mother began throwing herself from side to side on the bed & died

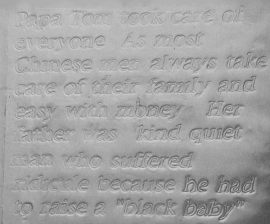

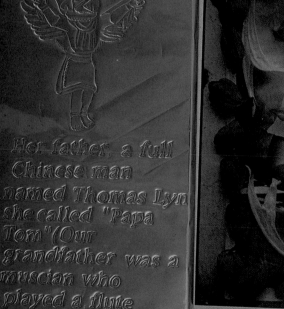

Her father, a full Chinese man named Thomas Lyn she called "Papa Tom"(Our grandfather was a muscian who played a flute He was living with Louise Hinds our grandmother she went to live with her her father and Aunt Lou who did not like her and treated her like Cinderella.

Aunt Winnifred Lynn ~ Albert Chong 2/2/95

Papa Tom took care of everyone As most Chinese men always take care of their family and easy with money Her father was kind quiet man who suffered ridicule because he had to raise a "black baby" who obviously was not his because she was having an affair with Douce (Beryl's father, who it seems was the person Aunt Lou really loved

One morning Winnie went to Aunt Lou told her "Papa Tom look sick and not moving Aunt Lou said"nothing wrong with him". She saw her father shudder was afraid and called a Chinese lady next door. her father was dead she had no one left. She remembers the old people passing her over her Father's body

Gavin Lee, *S.S. China,* **detail from the installation** *Concerning George,* **1994.**

see **14**

Maria Martínez-Cañas, *Virgen de la Caridad,*
from the series *Quince Selos Cubanos/Fifteen
Cuban Stamps,* 1991.

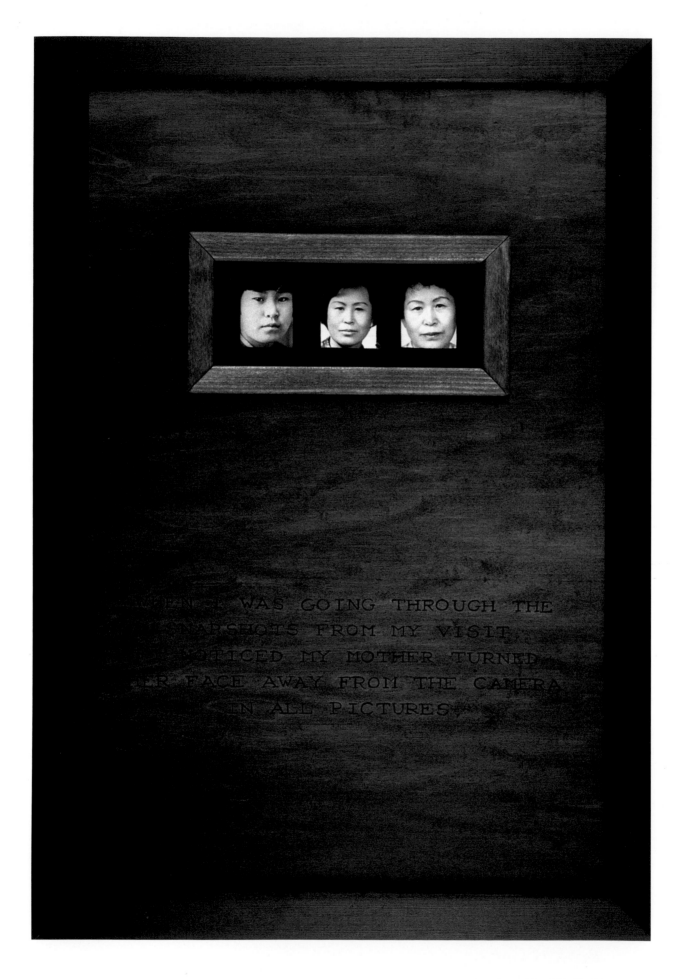

WAS GOING THROUGH THE
SNAPSHOTS FROM MY VISIT
NOTICED MY MOTHER TURNED
HER FACE AWAY FROM THE CAMERA
IN ALL PICTURES

Young Kim, _Distances #9,_ detail from the installation _Distances,_ 1992.

see **16**

DAISY CHAINS

BY REBECCA SOLNIT

Things in my family have a way of disappearing. My father's baby sister— my beautiful black-haired aunt—once showed me a whole box of family photographs, and the blank wall that lay behind my own beginnings gave way under a cascade of cardboard-mounted formal poses and strange unnamed faces in all the range from sepia to gelatin-silver gray. The one I remember best from all those years ago was of my grandmother and her two younger brothers at Ellis Island, or at least from around the time they came through Ellis Island. They were lined up in an overlapping row according to height and the conventions of the era's portrait photography. Their heads had been shaved for ringworm, and they had the hollow-eyed, underfed, haunted look of so many Jews of the time, these three bald children in their matching white sailor suits who had got themselves all the way across Europe and the Atlantic, and were about to cross another continent alone. When I asked about the photographs later on, my aunt said that the box of images—and with it the abundance and clarity of our past—didn't exist, and I must have imagined the whole thing. Last time I asked, she said the box existed but had vanished.

Photographs, which are supposed to serve as the anchors of an objective past, are as unstable as everything else that constitutes my paternal family history of myths, contradictions and silences. (It's a kind of family history that is, I suspect, more common than the reliable family histories that dominate literature.) I have rarely heard the same story twice, and if I repeated a story I remembered, it was denied or retold in a completely different version. In some ways this family history resembles, on a small scale, Eastern European history itself, in which countries are devoured and regurgitated by empires, borders fluctuate in disregard to language and culture, in which purges and pogroms eliminate factions and populations, in which the past was suppressed with the aid of an airbrushed photograph, so that images keep pace with the times and those who disappeared from the world also disappear from the pictures of it.

It may be, too, that truth itself was not a fixed quantity for my family, poured as it was back and forth from the various languages they spoke, just as emigration didn't constitute the same kind of displacement for people whose diaspora had begun so long before. The father of the children with the shaved heads, my great-grandfather, had emigrated early in this century from Bialystok, which had long ago been Lithuania, then Poland, was once held by Napoleon's troops, was Russia during the time of their emigrations, a war zone between Germany and Russia during World War I, occupied by the Red Army in 1918, then nationalist Poland, which was occupied by the Germans who would make both the Jews and their artifacts virtually disappear. The disappeared include, so far as I know, all but one member of my family who didn't emigrate. And so the city sat through fluctuating definitions, through the Communist era and into resurgent nationalist Poland, with its now-diminutive Jewish population. This is not to say these ancestors of mine were Russian, or Polish, though Jews had been in Bialystok since 1548. At home they spoke the medieval German dialect Yiddish, though they weren't German either, but the children of the diaspora that had begun in Israel/Palestine almost two millenia before. Another language, Hebrew, was preserved for other uses. An indelible image of a then-imaginary homeland kept its speakers from melting into their surroundings.

My grandmother's mother disappeared too. The three bald children probably didn't know they were already motherless at the time of the photograph, though they hadn't seen either parent in many years. As was the tradition, their emigrant father sent for his wife and then his children as he established himself in the New World—in Los Angeles, to be exact, which had for a while the second-largest immigrant Jewish population in the U.S. Or that's what I was once told, when I was told that my great-grandmother disappeared somewhere between Eastern Europe and the American West. I used to imagine all the things that could happen between the two places, picture her getting off a train somewhere on the prairie, getting lost and staying lost, starting up an unimaginable new life unlike the one allotted to her by her family, stepping out of the turbulence of an Isaac Bashevis Singer story into the calm of a Willa Cather novel.

For a long time, I imagined that the woman in Lewis Hine's 1905 photograph *Young Russian Jewess at Ellis Island* was my mysterious great-grandmother; if I could have believed it long enough and well, I might have assimilated it into my family history, or mythology. It's a strange image, one that seems to have drifted across the history of photography. Made by Hine during the turn-of-the-century debate over immigration, it was seized upon by Beaumont Newhall as an example of documentary-in-the-abstract for his *History of Photography,* though it would be hard to say what it documents nowadays beyond a brooding, intense face in an indistinct, soft-focus background. It would make more sense as an example of Pictorialism, since it's less about information than mood. A woman with a scarf or shawl pushed back just far enough to show her dark hair, parted in the middle and not very recently washed, looks at something past the camera, neither intimidated nor engaged with it. Only her cloth coat with its asymmetrical closure places her as being from the far eastern fringes of Europe.

Up close she is nearly beautiful, but from further away you can see the skull in the set face of this emigrant, as if through

hunger, exhaustion, fear she is close to other borders besides the national ones. Above her shadowed eye-sockets, her forehead gleams as white as the sky behind her. It's as though we can see through it to the same distant pallor of the sky, or as though both are only absences on the paper, a forehead and a sky that imparted no silver to the print. Ellis Island, which in most photographs appears so overrun by people, is empty and still here. The only thing that seems specific to that island of emigration are the bars behind her, which seem to be the fenced walkways through which lines of people were processed, but there is no one in them in this picture. This image of such a private and solitary moment in the packed bustle of Ellis Island is a document of an anomaly. Another impact is in the title, *Young Russian Jewess at Ellis Island*, a novel in one sentence about a particularly vulnerable person poised between two worlds, pinioned by history.

This is how one pictures the angel of history. His face is turned toward the past. Where we perceive a chain of events, he sees one single catastrophe which keeps piling wreckage upon wreckage and hurls it in front of his feet. The angel would like to stay, awaken the dead, and make whole what has been smashed. But a storm is blowing from Paradise; it has got caught in his wings with such violence that the angel can no longer close them. . . . This storm is what we call progress.[1]
—Walter Benjamin

Later on, the story about my great-grandmother's disappearance was revised: I was told that her husband had had her committed to an insane asylum as soon as she arrived, perhaps to get her out of the way. When my grandmother emigrated to Los Angeles some years after her mother had departed Russia, her father—my great-grandfather—was remarried and had another daughter, young, adorable, English-speaking. My grandmother grew up, learned English (though she spoke it with a heavy Yiddish accent for the rest of her life), and joined, according to another photograph, a ladies' hiking club: stalwart young women in knee-high lace-up boots and bloomers so uniform they look like a military group. She married another immigrant from a nearby town in the Russian pale sometime in

the late 1920s, my grandfather, who was brought over by his older brother after he was caught up in the throes of the Russian Revolution. He had survived the turmoil of the revolution by smuggling food across the Russian- Polish border, had once been badly beaten by the Polish border guards and another time escaped detection by joining the Red Army, where he was supposed to have been Trotsky's flag boy. Or so I was told. I've always had the impression that he was so small—which I know from photographs and stories; I only met him once—because of malnutrition, since my father, fed upon California's bounty by a doting mother, was a foot taller than him.

My grandfather's older sister, my father told me, was shellshocked by the pogroms and wars she'd lived through in Brestlitovsk, and never left her L.A. house without a large bag of fruit as provisions in case a disaster suddenly broke out around her again. When

she baby-sat him, rather than tell him bedtime stories she showed him the fruits and named them again and again until he fell asleep. Maybe this is my real history, a narrative of paradise: the circular litany of the surety of food and the names of the fruits in an as-yet smogless Los Angeles amid the orange groves and mountains. Maybe Nuestra Señora la Reina de Los Angeles, after whom the city was named, is the Angel of History in this particular private history, the angel from Walter Benjamin's ninth thesis of history, that angel who cannot close his wings or make whole what has been smashed, because a storm is blowing from Paradise and the wreckage is mounting skyward.

The brother of this fruit-carrier, my grandfather, was a rogue and a gambler. Later

in his life, after he had divorced and moved to El Paso, he became a border smuggler again, though this time Mexican housewives carried the goods. My father never talked about all this. I can count three stories he told me about his family and childhood. He was tall and blue-eyed, slender and fair-haired through his twenties (though not in my time), seldom taken for a Jew in a society whose anti-Semites knew what Jews looked like. He was part of that great universalizing, assimilationist wave of the 1950s that thought the past was unnecessary baggage, ethnicity something that would disappear into the melting pot of America, if it hadn't been checked at the gates of Ellis Island. My father's younger sister, my aunt, was as dark as her mother, and when she lived with her father in El Paso she was routinely suspected of being an illegal alien. She had to emigrate over and over again from Juarez, and since she acquired a Spanish name from her second husband many people have assumed she is Hispanic. She has been the keeper of the family stories and photographs, though they have served less as buttresses of a stable sense of the past than as phantasms and fictions that metamorphose continually in accordance with the needs of the present—but all histories and photographs do that, public as well as private.

Another time, my aunt had hung a picture of her mother, my grandmother, in her house, another image I saw only once. It showed a child standing next to some roughhewn wooden farm implement. Had photography existed five hundred years ago, it wouldn't have been hard to imagine this to be a photograph from that time. It conveyed how backward, how almost medieval, was the world from which my grandmother came, when she came to the sunny, optimistic boomtown of Los Angeles in the teens or twenties. My grandmother was supposed to have been a paranoid schizophrenic. That was the diagnosis she was institutionalized with during the last decades of her life. I always thought, even before I saw the picture of her in medieval Europe, that her world-view might have been perfectly reasonable under the circumstances. The doctors who treated her were unlikely to have experienced such

profound instability: disappearing mothers, the vast gap between medieval Bialystok and glittering Los Angeles, the three or four languages she lost and the English she never completely acquired, the almost complete annihilation of the world she came from and the relatives she left behind. As the body completely replaces itself on a molecular level every seven years, so the world seems to replace itself in its essentials every generation, with what survives recontextualized as antiques, relics, ruins—the bones of an unrevivable past. In my grandmother's case, everything changed more quickly and violently.

The people in the photographs my aunt sometimes showed me seemed to have little or nothing to do with me; their faces, their poses, their clothes spoke more of time and place than of family and resemblances. The technology and conventions of photography have given a particular look to each generation's images, while history, fashion and food have left their impressions on everyone, so that nearly everyone in a given era has a kind of kinship to each other they don't to other generations. Before the 1960s, light and air themselves seem to have had an almost undersea depth and luminosity, in which skin glowed opalescently and everything had a faint aura slaughtered by the newer, flatter films. I think most Americans who didn't live through it think the Depression took place in a world of rough-hewn but secretly seductive black-and-white surfaces, that the early part of the century was full of stern, hollow-socketed faces above body-belying clothes, with everyone up against a wall somewhere. This is the world of those apparitional photographs of what doesn't look like my family.

It isn't only an immigrant story. My friends Mary and Carrie Dann, Western Shoshone land-rights activists who ranch on the land their father ranched in the unrecognized sovereign nation of Newe Sogobia, have two handsome hand-tinted oval photographs of the grandmother who raised them hanging on the ranch house wall. They tell me this grandmother, whose memory stretched back almost to the time before whites invaded their part of Nevada, never slept in a bed, never lived in a board house. The photos of this woman in robes sitting tranquilly in front of her wickiup in a scratchy atmosphere now face a television, a VCR and a bank of those smooth color portraits from schools and department stores. Salman Rushdie once remarked, "It may be argued that the past is a country from which we have all emigrated, and that its loss is part of our common humanity," but went on to say that such a universal displacement paled before the situation of emigrants from languages and countries.[2] There are cases, such as the Danns', where the world and the borders have changed around them; some immigrants didn't have to move.

My paternal grandmother appeared in my life as abruptly as her mother must have disappeared. No one mentioned to me that I had a grandmother other than my mother's charming Irish American parent in New York until one day on a trip to Los Angeles, when I was about six. We drove up to a tall cement building in a sea of concrete, and this unanticipated ancestor came down and kissed me. She left a smear of lipstick on my cheek, and my mother turned around and gave a little scream because she thought it was blood. Later on, my grandmother was transferred to the state mental hospital in Napa, not far from where we lived. For years I thought it was a retirement home, because she was on a ward populated entirely by elderly women who, thirsty for the sight of children, used to flock around us and give us coins when we visited, and because no one told me otherwise. It was an uncannily tranquil place full of broad lawns scattered with trees casting pleasant shade around them, the place where Carleton Watkins spent his last years and is buried, almost the only place he went that he didn't photograph. Only rarely did a shriek pierce the calm. When I try to recall it now, I remember the redwing blackbirds we used to see in the San Pablo Bay marshes on our way there; and an afternoon or many afternoons my younger brother and I spent on one of the lawns there making daisy chains, which my grandmother wore till they were wilted around her vast bosom and hunched back; and I remember the cherry cider stand under a huge tree we used to stop at on the way home, and the taste of cherries. It never occurred to me to ask her about the past, and she probably wouldn't have had much to say, because electroshock tends to destroy memory. I can only surmise that she was, like her mother, an internal exile from the nightmare of history.

A few years ago, one of my brothers visited our cousins in Mexico City. These were our grandmother's first cousins with whom she had stayed after her parents had emigrated, and who emigrated to Mexico when she came to the U.S. The patriarch of that family, who had started out as a street peddler and become a wealthy art collector, remembered their childhood together in Bialystok and told my brother that our great-grandmother had never reached Ellis Island and the U.S. at all, but had been put in an asylum in Russia. When I heard that story, the image of the *Young Russian Jewess at Ellis Island* suddenly vanished from my imaginary family album and became an impersonal image, a Lewis Hine image from the world called documentary, and the nameless woman from whom I'm descended became faceless and unimaginable again. 🔦

NOTES

1 Walter Benjamin, "Theses on the Philosophy of History," *Illuminations* (New York: Schocken Books, 1968), pp. 257-8.
2 Salman Rushdie, *Imaginary Homelands: Essays and Criticism,* 1981-1991 (Penguin Books, 1991), p. 12.

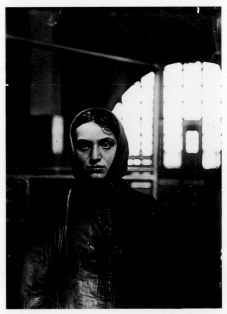

Lewis Hine, *Young Russian Jewess at Ellis Island,* 1905. Courtesy George Eastman House.

LUKAS FELZMANN

THAT WHICH HAPPENS

IS SO FAR AHEAD OF

OUR KNOWING THAT

WE WILL NEVER CATCH

UP AND NEVER FIND

OUT WHAT IT REALLY

LOOKED LIKE.

Das, was geschieht, hat einen solchen Vorsprung vor unserem Meinen, dass wirs niemals einholn und nie erfahren, wie es wirklich aussah.

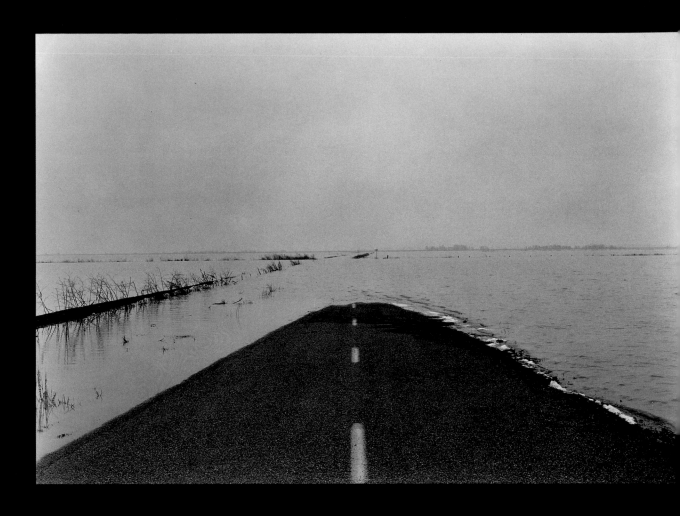

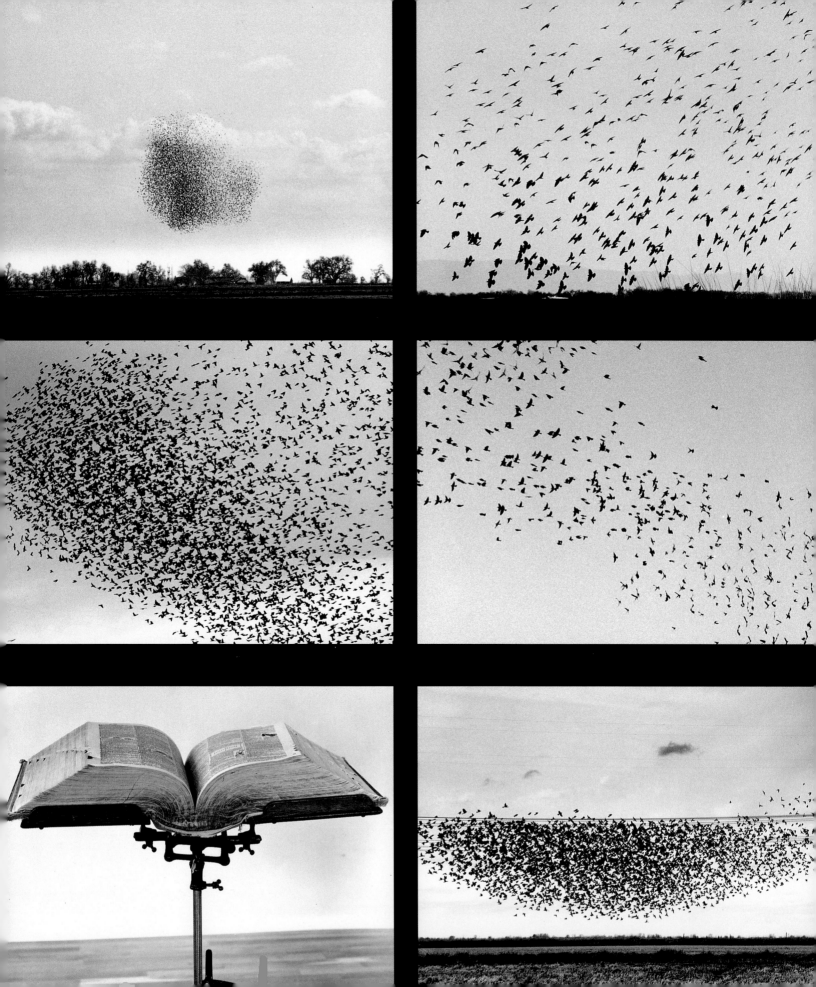

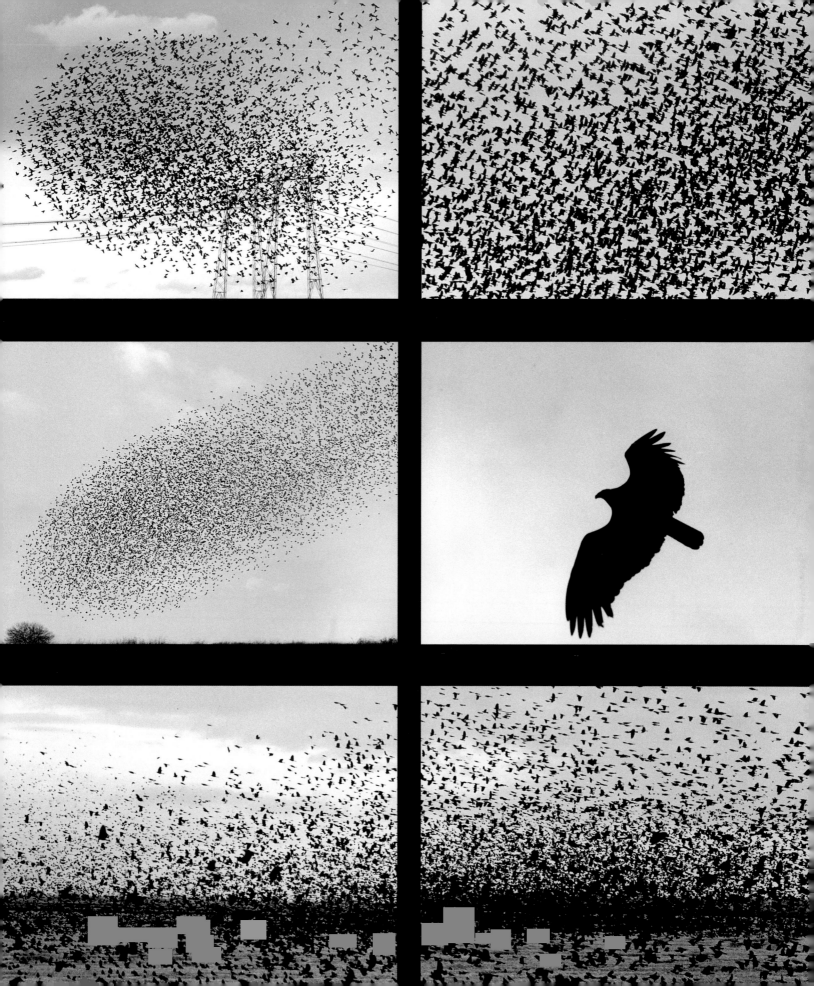

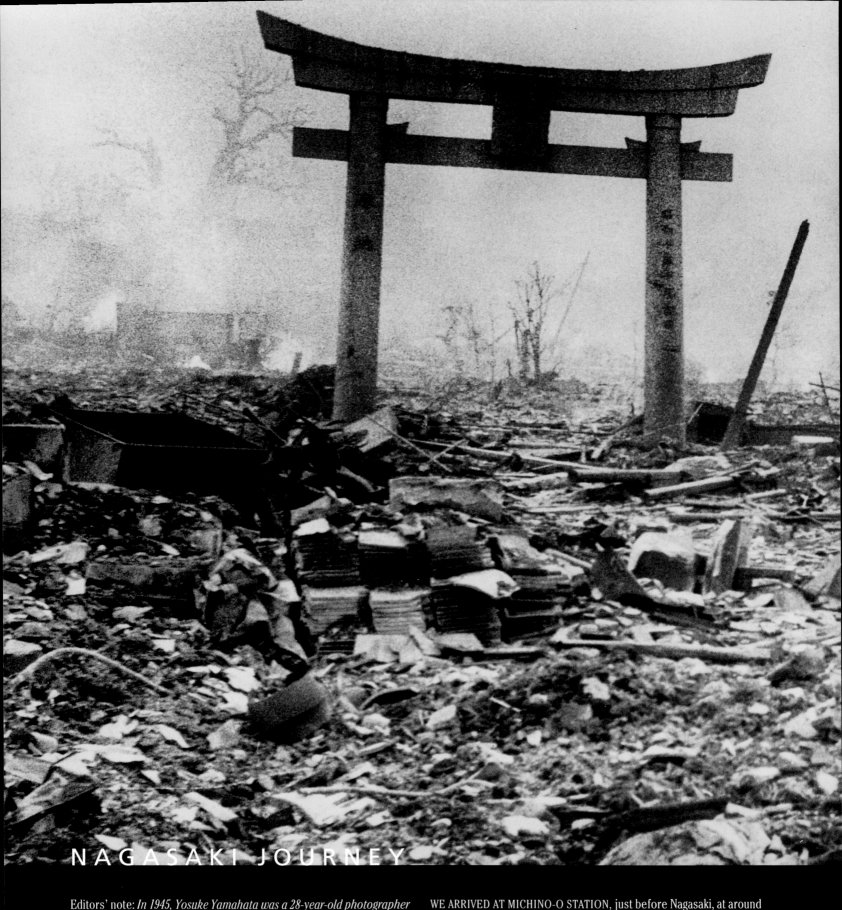

NAGASAKI JOURNEY

Editors' note: *In 1945, Yosuke Yamahata was a 28-year-old photographer on assignment with the Western Corps of the Japanese Army. He was sent to photograph the effects of the August 9 atomic bombing of Nagasaki, the second use of what the Japanese government then referred to as a "New Style Bomb." He arrived in Nagasaki on August 10, 1945 and began to photograph at daybreak. By nightfall, he had taken more than one hundred photographs. Yamahata, who died of cancer in 1966 at the age of 48, remembered the events of that day in an essay written in 1952.*

WE ARRIVED AT MICHINO-O STATION, just before Nagasaki, at around three in the morning. I remember vividly the cold night air and the beautiful starry sky. Descending a sloping path that ran along the mountainside, and crossing over the ridge of the mountains, we reached the front gate of the Mitsubishi arsenal. A single sentry holding a fixed bayonet stood guard before the closed stone gate, and when we inquired about the situation within he told us that everything was in ruins, and that the city of Nagasaki was even worse off. ● A warm wind began to blow. Here and there in the distance, I saw many small fires, like elf-fires, smoldering: Nagasaki had

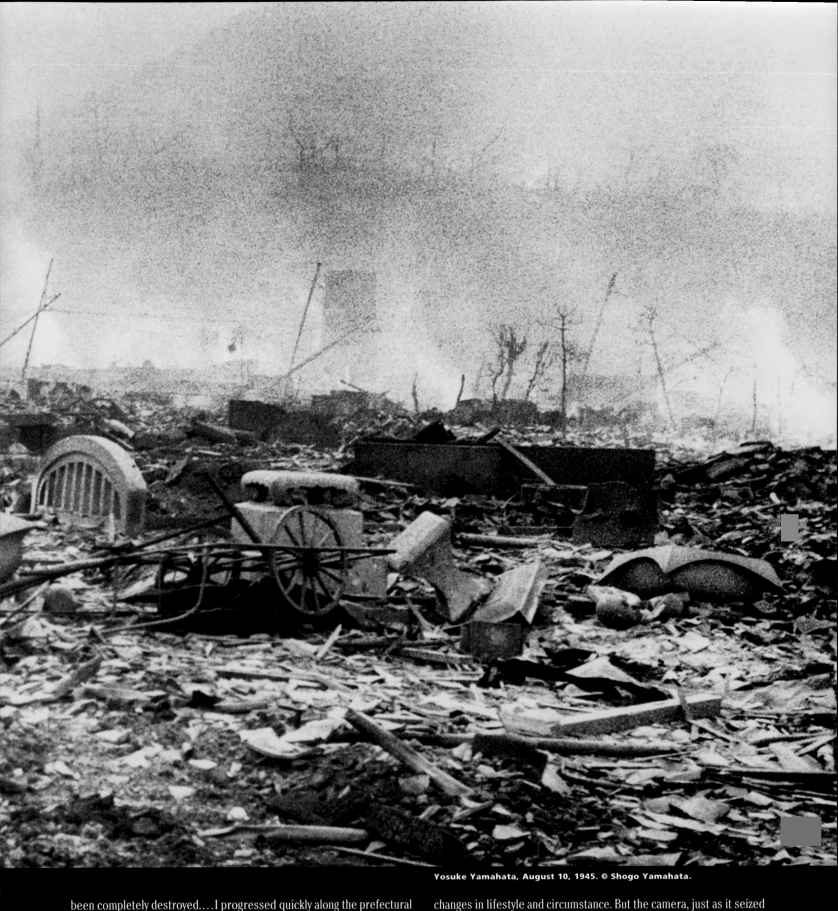

Yosuke Yamahata, August 10, 1945. © Shogo Yamahata.

been completely destroyed.... I progressed quickly along the prefectural road that ran down the middle of the plain. Stepping carefully in spite of our hurry, we nearly tripped on the human and animal corpses lying in our path. ● It was truly a hell on earth. Those who had just barely survived the intense radiation—their eyes burned and their exposed skin scalded—wandered around aimlessly with only sticks to lean on, waiting for relief. Not a single cloud blocked the direct rays of the August sunlight, which shone down mercilessly on Nagasaki. ● Human memory has a tendency to slip, and critical judgment to fade with the years and with changes in lifestyle and circumstance. But the camera, just as it seized the grim realities of that time, brings the stark facts of seven years ago before our eyes without the need for the least embellishment. Today, with the remarkable recovery made by both Nagasaki and Hiroshima, it may be difficult to recall the past, but these photographs will continue to provide us with an unwavering testimony to the realities of that time. ▽
From Nagasaki Journey: The Photographs of Yosuke Yamahata, *an Independent Documentary Group project (Rohnert Park: Pomegranate Artbooks, 1995).*

STILL CRAZY

I WAS BORN IN A TOWN ON THE COAST OF JAPAN in 1950, and as I grew
up I witnessed the transformation of the coastline during this period of
rapid economic growth. Therefore, it is no accident that I came to view
Japan's 53 nuclear power plants in 18 locations—situated by the sea due to
the need for cooling water—as scenes that typify present-day Japan. Will
we live happily ever after with this most convenient of inventions, or have
we created something inordinately dangerous that cannot be controlled?

Like it or not, we already are living close together with nuclear energy.
When I think of these power plants, destined to be pulled down little more
than forty years after their construction, I imagine how their settings will
look a half-century from now, when vast quantities of radioactive waste
with a half-life of two million years are left behind. ♀
—Taishi Hirokawa

**Taishi Hirokawa, *21 September, 1991*. From the series *Still Crazy: Nuclear
Power Plants as Seen in Japanese Landscapes*.**

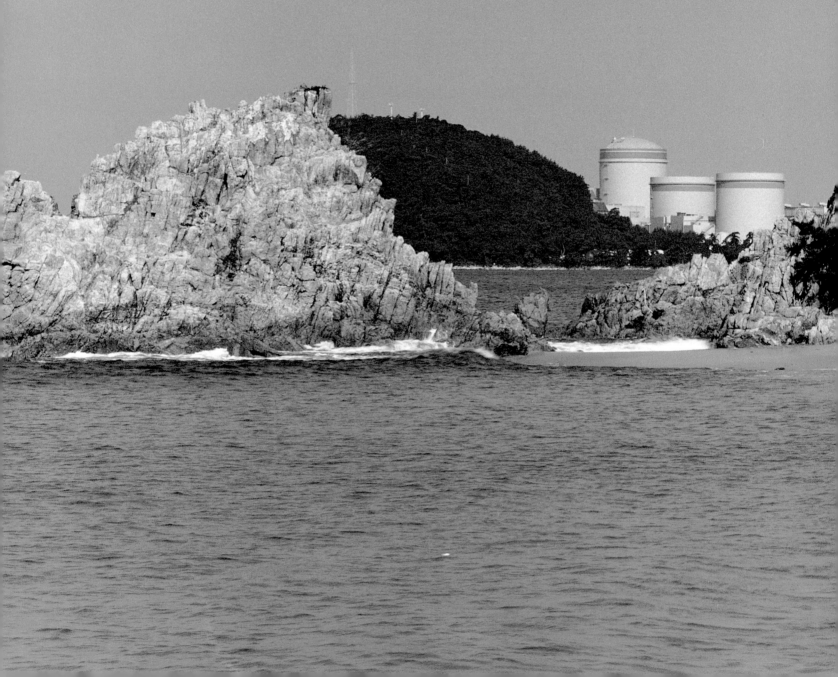

The Photograph Album
STORY BY NICOLE COOLEY

The girl is sleeping. She is ten, maybe twelve. A line of elephants is carved into the wooden headboard of her bed, their trunks lined up. The wallpaper is patterned with circus figures: lions, three-legged horses, a woman swinging on a trapeze.

The man stands over her bed with his camera, steps closer, adjusts the flash gun.

The shutter clicks. The flash is an explosion of light. The girl wakes up. She begins to cry.

Why begin with this? Is this a story that could start anywhere?

"Once upon a time, in the city of _____, there lived..."

No—the story starts with what was saved. A single clue, what my father left behind when he disappeared: a box of photographs. No family scenes, no birthday parties on the beach, no portraits from school. The pictures are all the same: the child sleeping. No photographs of my father. But he was there. The camera always in his hands.

Three months ago, my father left Sarasota, the city where he was born and had lived all his life.

Why would a man leave a house where he lived entirely alone?

Why would a man leave when he had nothing to escape from?

For six weeks, the Florida State Police conducted a search for him. They dragged the lagoons. Their searchlights trailed the edges of the marshes. The policeman stood on the porch, tapping his pencil against his clipboard, saying, We've come up with nothing. We want to question people who might have known him. Didn't your father have any friends? He wanted a picture to show around the neighborhood and looked at me suspiciously, eyeing the camera hung on a strap around my neck. No pictures? No pictures at all?

The search was given up soon after. The police had no leads. The policeman with the pencil: There is no reason to keep this case open.

The case was filed in a cabinet in the 37th Precinct downtown, my father's entire story as it's known, three neatly typed pages.

The search is not over.

The story does not end here.

I open my investigation into my father's life.

Early Saturday morning when I am nine, lying in bed in the room I share with my grandmother, Nana. Someone has thrown the curtains open; sunlight scatters on my circus dolls on the bookshelf, on the lady sword swallower figurines my father has given me. I hate the lady sword swallowers. Dressed like ballerinas, they lift their swords high in the air and smile tiny, evil smiles.

The door to the room bangs open. My father walks over to my bed, wearing a dark suit and tie, dressed for work. My father never enters my room; I know something is wrong. I am afraid that I have slept for longer than a single night, that I have slept for days and now it is a school morning again. My father's face is pale. His mouth is trembling.

"Read this." He throws a newspaper on the bed. "The bottom of the page."

I find it, under "News from Siesta Key": "Woman, thirty-five, loses control of car on the Sarasota Bay Bridge. Bridge police believe that death occurred upon impact with the bridge side rails. Divers have recovered the front door of the car. The woman's identity has not yet been released, pending the notification of relatives." Beside the article is a blurry picture, taken in the dark, of the middle section of the bridge, its rails knocked out. Cars are stalled in a long line beside the empty space.

"Your mother is dead." My father's voice is flat. Then, louder, "Are you listening, Ellen? Your mother is dead."

I do not look up from the newspaper page. I read the paragraph again. I stare past my father to the window, thinking, *Red curtains, the curtains in this room are red, you see red if you look straight into the sun.*

"Get dressed." My father pulls the blanket from the bed. I yank my nightgown over my knees. "Go help your grandmother."

I hold the newspaper closer to my face. There are two policemen in the photograph, pointing to the air above the dark water where my mother's car had been.

The story could start with New Orleans, where I was living when the landlord of my father's rented cottage called me. The production company was in the middle of editing a documentary on silent films. The part of the documentary I'd been hired to research, the five minutes devoted to "Women of the Silent Era," had been cut in favor of a segment on Charlie Chaplin's childhood. "Their faces are interesting," the director said, studying the photos I'd collected of Louise Brooks, Lillian Gish and Pola Negri. He shrugged. "We need somebody to do research on Chaplin's half-brother. You can help with that."

The company was under contract to keep paying me until the documentary was done, so I took some reels of film, locked myself in one of the screening rooms, and watched one after another, all the films the director did not plan to include: *The Temptress, Love 'Em and Leave 'Em, Our Dancing Daughters...*

Until the landlord called. "Is this Mr. Goodman's daughter? You'd better come home."

After the Florida police gave up the search, I moved into my father's cottage on a Siesta Key. I had never been in his house before, but I knew he'd return there if he came back to Sarasota.

I stood on the front steps. I was scared. I rang the doorbell though I knew the house was vacant, then fitted the key into the lock. I took a deep breath and walked inside.

see **30**

The walls were clean, white stucco. No paintings or posters. Dressers and tables free of clutter. I looked for open books, cups left unwashed in the sink, notes he scrawled to himself. I would have settled for anything, a piece of paper with *Pick up milk* written on it, an old magazine. There was nothing to offer any clue of his daily life.

I photographed each empty room four times, one shot from each corner.

I found the shoebox full of photographs under his bed. The girl in the pictures was ten, twelve, fifteen years old. I arranged the black-and-white squares on the floor in a line. Do the photographs arrange themselves into a story?

It is not much of a story, but he would not want the story told.

Her father's shadow appears at the end of the bed. He wears a white suit, leans closer. No sound. She holds herself still, waiting for the light.

In New Orleans, one scene repeated, one shot, carefully, expertly composed.

I stood at the screen door of my house, in the center of the frame. Late in the evening or maybe morning. The man on the other side of the door, on the porch, was not visible, but he was there. I stood in the doorway, the belt of my robe pulled tight, my hands in my pockets. The man was leaving. I wanted him to leave. I had photographed him and now I had no use for him. Then was the part where I told him goodbye.

He was not visible. I didn't see him. Instead, I was seeing myself as he saw me—

Did the man think, She is pretty, she is ugly, she has an ordinary face? Her expression was blank. He couldn't read her.

This was how she wanted it. She had to keep anyone in her new life from knowing her.

The man left and the scene changed. I closed the door, went back inside my house.

There are facts about my father and there are lies. Facts: He works at the Sarasota Visitor's Bureau downtown. I visit him there once, with my mother. I am young. He has an office at the back of the building, full of cabinets. He shows the office to us, pointing out the stacks of papers and the blue-lined graphs. My mother leans against the wall, her hat tilted over her face. (Her face is shadowed. I can't see her face.)

She sighs. "Tell her how what you do all day is something nobody gives a damn about."

My father ignores her. He turns back to me, opening the top drawer of his desk to show me a protractor, a transparent ruler, a set of colored pens. He holds the pens gently, lifts the maps up by their edges, as if they are delicate. He handles everything with care.

Another fact: My father wanted to work for the circus, which stopped spending winters in Sarasota around the time that I was born. The site was turned into a museum. My father had told me that my grandfather had a job with Ringling Brothers. He cleaned

cages in the animal barn. I know this, but my father created another version of the story in which his grandfather ran the circus from the center ring.

One of the lies: We pretend that my mother has simply left. We pretend she takes her coat from the hall closet one evening and shuts the door of the house behind her.

Nana is always in my room now, in her bed. The room smells of talcum powder and unwashed sheets. I try to make her take her medicine. Nana used to open her mouth like an obedient child as my mother slid the spoon in. For me, she clenches her teeth and turns her face away. She won't come to the table, so I bring her meals to her on a tray.

Sometimes, I wake up in the night and hear her crying. I cover my head with a pillow to drown out the sound.

The truth: I could never write the story of my mother. A week after her death, she is gone from every place in the house. He takes her clothes from the closet, he gives away her wedding china, he throws her bottles and jars on the bathroom shelf into the trash. One day, it occurs to me where I can find her: in the photograph album under Nana's bed. I look for the album; the album is gone. I go into the sun room where my father sits reading the newspaper. "Where is the picture album?"

He points without looking up. "Where it's always been."

I know this is a lie. I find the book on the wicker table in the sun room. The first page, where her baby picture had been, is blank. Yellow glue stains dot the page. I turn. I remember some of the pictures on the next page—my mother at eleven on a painted pony, in her high school uniform, a plaid skirt. The page is empty. Except for the wedding photograph from which my mother's face has been removed. Neatly, a perfect oval missing from the center of the picture. Her white dress remains, her hands still hold a fluted glass. I flip quickly through the rest of the book; everywhere, my mother's face has been cut out.

"Put that down." My father crosses the room in long strides and snatches the book from my hands. "Your mother did it," he says quietly. "You shouldn't look at that. I didn't want you to see that. Things are different now, Ellen, and I want you to forget about that time."

I know my father wanted me to see the album. He left it out, knowing it was only a matter of time until I saw it. The next day, it disappears.

I know something else too, something I do not want to remember. Last year, I came home from school and found my mother in the kitchen. It was too early for her to be cooking dinner. She was hiding something in her lap. Scraps of paper littered the table. There was a glass of transparent liquid at her side and a glass of ice. "Get out," she said when she saw me. "Don't you dare come in here."

I haven't been back to Florida in ten years, since I left for college. That was the last time I saw my father.

One afternoon I forced myself to leave his house and take the bus out to the Ringling Estate. The parking lot was full of cars and campers. I walked through the grounds where everything was in bloom—oleanders, crotons, date palms. Everything was too

bright—as if the landscape had been filmed in Technicolor. Electric orange flowers, leaves the color red it made you nervous to look at, all under a gleaming blue sky.

I followed the path to the circus' old winter quarters by the bay, where the performers and animals lived when the circus trains returned home after summers on the road. The show trains were repaired and repainted during the winter and in the spring the circus would leave again. The animal barn was full of tourists but wire cages still lined the walls, where once there were dwarf mules and polar bears, kangaroos and pygmy elephants. A woman wearing a badge that said "Circus Museum Docent" pointed out the practice rings where rehearsals had been held each day. The crowd of visitors nodded and smiled.

I was a visitor. I hid my camera inside my jacket.

Next to the Bengal tiger cage, I found a family that had drifted away from the tour. A father and his two children, a boy and a girl. The father was arranging his children with the empty cage as a backdrop. He moved them into place, then stepped back to take a picture, when he noticed me, standing nearby and watching.

"Would you mind taking a picture of us?" he asked. "The camera is real easy to use. Just stand back over there and press the red button. I'll show you how to do it."

I had not spoken to anyone for days. If I started speaking I sensed that I would not be able to stop. I would talk and talk to this man till he began to back away, frightened, leading his children out of the museum, shielding them from me. I would be left standing alone, telling my story to myself.

There was so much to say that I did not say anything. I took the instamatic camera from his hands. The children posed against the tiger cage. They seemed to be used to posing; they had probably posed hundreds of times for their father on that vacation. I wondered where the children's mother was. Dead or disappeared, I thought. The father rested his arm on his daughter's shoulder, gently, protectively.

I knew photographs do not tell the whole story. I snapped the picture. At night, at home, the father could have been doing anything to that girl.

Another scene my father would not want to remember—once, shortly before he brings home his camera, I take a picture of him. With a Brownie camera given as a favor at a birthday party. I sneak into the sun room, creep up behind his chair, then jump out and press the button.

My father rises from his chair, his face dark red. "Give me that." He reaches for me.

I hide it behind my back. In one quick movement, he wrenches it from my hands, twisting my arm hard. He takes the camera outside and throws it in the trash.

In New Orleans, she liked to photograph the men while they were asleep. She waited until their eyes closed, until their breathing became slow and even, until she was sure that it was safe to get out of bed. She slipped on her robe and took one of her cameras from the kitchen. She hid the cameras there, in the cupboards with her cereal boxes and soup cans.

She stood at the edge of the bed with the camera, holding her breath, as quiet as she could be. This was the moment she waited for as soon as she asked the men to come home with her.

She didn't want the photographs themselves. She wanted the moment, the split second where she held the camera in her hands and turned it on them. Recording their faces meant nothing to her. She never developed any of that film. What would she have done with those photographs? Men from the companies she worked for, men she met in the park or on the street. They meant nothing to her. She had no desire to save any of them.

My father wants me to have the set of circus dolls he collected during his childhood. The first one, a snake charmer, was given to me when I was born.

The others follow. When I turn seven, I am given the entire collection. My father brings three shoeboxes into my room and opens each one, lifting the figures from the tissue paper, laying the dolls out in a line on the floor. "Look, Ellen." My father names each figure for me. Here is the bareback rider, the wire-walker, the bear that rides a bicycle. I touch the ringmaster doll—he wears a red coat and a top hat.

And the other, more frightening figures: the albino family, the Siamese twins with their two mouths frozen in a smile. "Go on. Take them. They're yours now." My father pressed Tom Thumb into my hand. He closes my fingers into a fist. "I want you to have them."

My mother appears in the doorway of the room. "Why on earth would she want a bunch of stupid, old-fashioned toys?"

The truth is, I don't want them. I want ordinary toys like other children have, balls and tops and dolls with smooth, golden hair. My father's toys scare me. The albino family stares up at me with mean, pink eyes.

The first camera I bought for myself in college was a Minolta 35mm. It came in a small blue box with an instruction booklet: "*A MINOLTA 35mm makes it easy to capture the world around you. Or express the world within you. It feels comfortable in your hands. Your fingers fall into place naturally. Everything works so smoothly that the camera becomes part of you. You are the camera and the camera is you.*"

Nana lies in her bed, her face turned toward the wall. My father stands over her. "Get up now, Mother," he says. "This can't go on." I sit on my bed, twisting the hem of the blanket. "You two are impossible." My father turns and leaves the room.

Nana is whispering, then her voice grows louder and I see that she is talking to me. She says, "He was a bad baby. He refused to let me feed him. He wouldn't suck. I had to feed him with a teaspoon and pinch his nose shut so he would open his mouth." I cover her shoulder with a sheet. "A bad baby," she says again.

I don't know what else to do. I don't want to leave my room and face my father. I go over to the circus dolls on the shelf. The figures make a family: the trapeze artist mother, the lion tamer father. The children are human cannonballs and clowns. "Are you listening?" Nana says from the other side of the room.

see **32**

As soon as the girl blinks the light from her eyes, her father is gone. Across the room, in the other bed, Nana doesn't stir. The flashgun never wakes her. The girl will lie awake till morning, counting the hours off on the clock beside her bed. She draws her knees up to her chest, making herself small.

Florida winters. Days of rain. Soaking rains that fall for most of the day, and when the rain stops at night the air is more humid than before; the air is heavy, filled with water. The drainage ditches clog with leaves, the palms bending under the force of the wind.

Sometimes the street floods and becomes a river. Branches and porch furniture float away. Laughing and calling to each other, children row boats up and down the street. I watch from the window. My father does not allow me to go outside during the day because I am supposed to stay in and take care of Nana, but Nana will not let me touch her and pretends to be asleep when I approach the bed. Her eyelids flutter and I know that she is faking.

Two rats swim by the front steps. A boy in a rubber boat drops his cap and lets it float away into the waves. I am exhausted. When I rub my eyes, the skin burns.

It is the middle of February, and I have already missed fifteen days of fifth grade this quarter. "You have to watch your grandmother," my father says. "Some things are more important than school."

Each night, he comes home with another circus figure for me. These are made of cheap plastic, unlike his childhood toys. The collection on my bookshelf grows: zebras, tigers, polar bears. I never touch them now.

In New Orleans, at the end of the afternoon, before I punched out my time card, I turned off the projector and took an elevator to the storeroom in the basement of the building, an enormous room with a cement floor where the props for our documentary were kept. Painted posters advertising the early days of Universal Studios ("Universal Moving Pictures Are Mightier Than Pen or Sword"), kinetoscopes, metal dollies that were once used to run the cameras on.

There, I found a box of cards: *"Photos of Moving Picture Players—All True Likenesses."* I sat on the cold floor and looked through the box. Everyone was there. I held Douglas Fairbanks up to the light. He looked like my father, his hair slicked back and smooth, his lips parted in a small, sad smile. I hid the postcard at the bottom of the box.

On the box top was printed, *"Do not fail to get a set of these pictures for your postcard album, for the walls of your bedroom, or to mail to your friends."*

My father comes back from the dead or the bay or the sky or from whatever town he lives in now. He sits across from me. We face each other, but he does not look at me.

His cigarette burns down to a long ash. His face is tired. His hands shake as the shutter clicks again and again. One picture after another. He does not look at me. He does not look through the lens.

I cannot capture his attention. The light flashes on the floor. I do not appear in any of these photographs.

My mother's car lies at the bottom of Sarasota Bay. I can see it— the car sinks slowly into the sand. The fenders rust. Mollusk shells cover the metal. Fish swim in and out of the car through the missing door—eels, carp, angel fish with glittering yellow fins.

At the bottom of the bay there is no light. The bottom of the bay is a dark and silent museum. I want to go down there. I used to think that I could live down there. It would be quiet, calm.

I would be safe. I would sit in my mother's car and close my eyes. I would be alone. This would be a place where I could sleep.

The first production company I interviewed with in New Orleans after college was making a film about the circus. The director studied my résumé. "You're from Sarasota?" He moved his chair closer to mine. "You must know about the circus then."

"A little." I did not want to be asked questions about my life.

"We need a research assistant to travel back there and collect footage of acts from the archives."

"I would prefer to work here," I told him.

"Well, that's a shame, because we could use you as a resource." The director touched the tips of his fingers together, a pose that I could tell was designed to make me believe he was thinking, appraising my situation. "You must still have family there, right?"

"My parents are dead." It sounded like a lie as soon as I said it.

"I'm so sorry." The director rolled his chair away from me, back behind his desk. He stacked some folders into a neat pile. "We have a position open to do research in the office."

"Could I help with filming? I've had experience," I said.

The director didn't look at me. He pretended to be very busy arranging his pens in a line on his desk. "We leave the camera work to our permanent crew. You'll have plenty of time to work with cameras."

My first job was to sit in the film library and read through old copies of *The National Vaudeville Artists' Annual*, looking for information on certain performers. I had been assigned the Fire King and the Human Hairpin. I collected facts about Ivan Chabert, the Fire King: He drank boiling oil and burned the shirt off his back in his act. There were pictures of him standing on lighted candles. The Hairpin could extend his height up to twelve inches. During his act, he would ask the largest man in the audience for his coat and then expand his chest to such a size that the coat would no longer fit him, and then, a few minutes later, he would make himself so small that he could wear the jacket of a child.

I imagined my father swallowing fire. A look of terror crossed his face as he lowered the flaming sword into his mouth. I made him grow larger, smaller. He was a little boy. I turned the camera on him, flashed the light in his face, watched him cry.

His pictures are never taken during the day. In daylight, the camera disappears. The girl does not know where it is kept.

She tries to stay up all night, sitting in the kitchen with her schoolbooks spread open on the table. It is hard for her to keep

continued on page 64

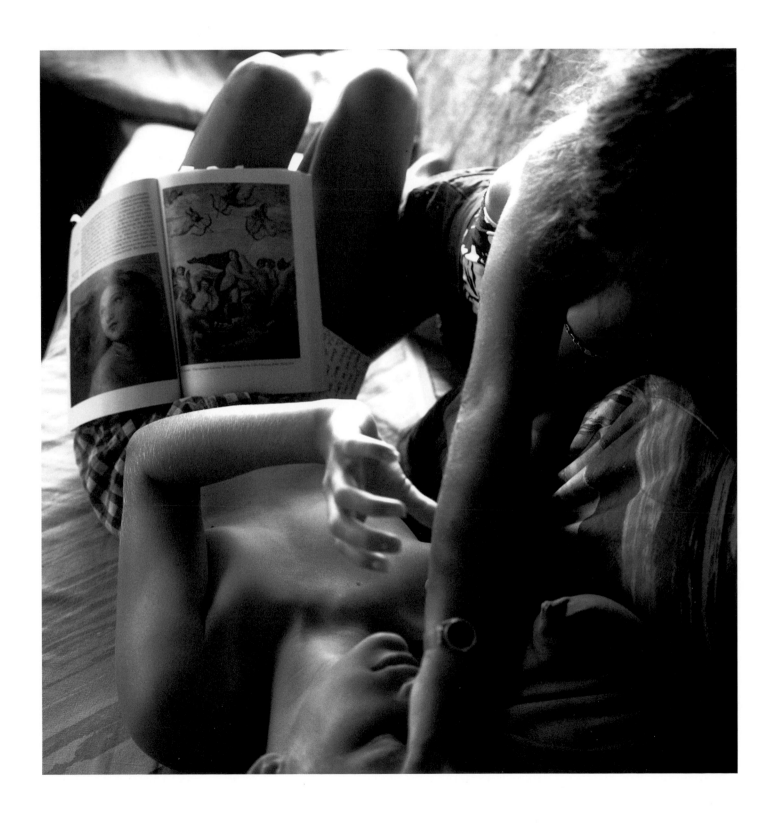

Art #2, 1994.

Facing page: *Orange Virginia*, 1990.

see **35**

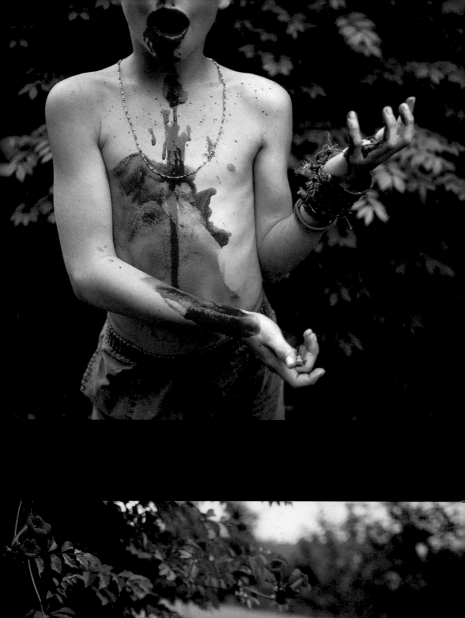
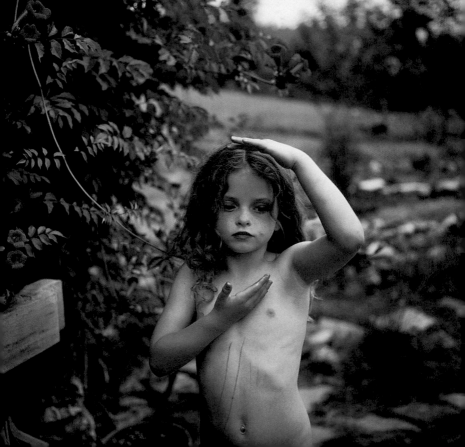

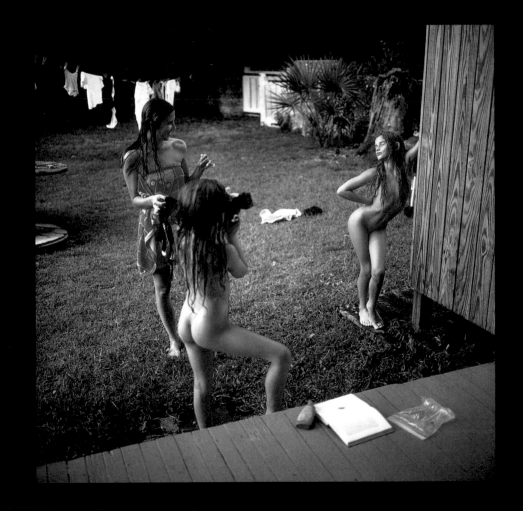

Vamping on Cumberland, 1992.

Facing page:
Bloody Nose, 1991.
Trumpet Flowers, 1991.

see **37**

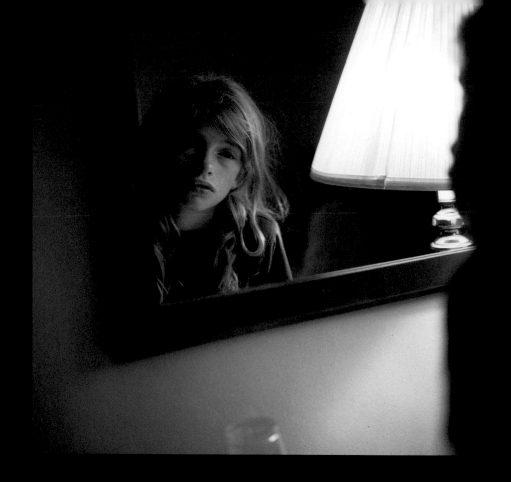
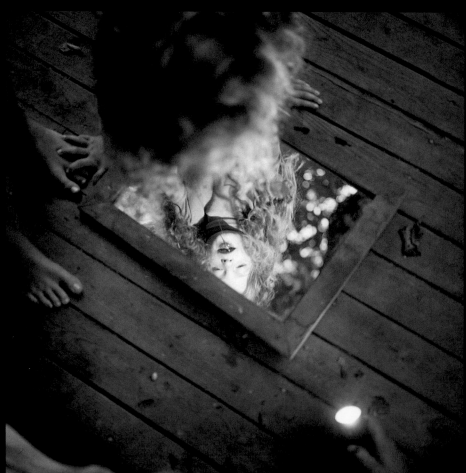

Thanksgiving, 1990.

Facing page:
Jessie in the Mirror, 1991.
Virginia in the Mirror, 1991.

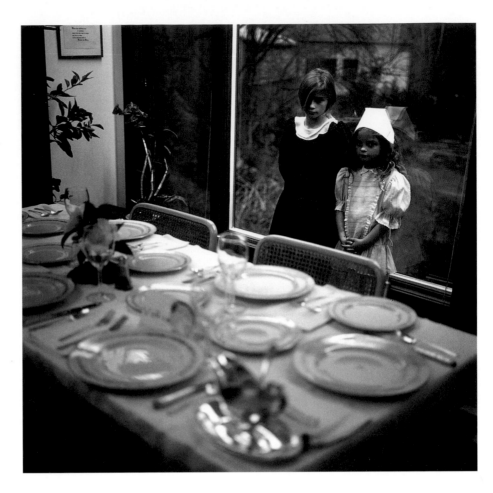

MANN ACTS

FOR MORE THAN TWENTY YEARS, Sally Mann has been trying to convince us that Eden exists right here on Earth—or at least on her particular corner of the Earth, in rural Virginia—and she has the angels to prove it, in the form of her two daughters and one son. Their prelapsarian state of grace is semiotically signaled by their nakedness. Still, they are not entirely innocent; their encounters with the world of the camera unavoidably have engaged them in a contest between good and evil. Dirt and blood and scrapes big and small taint them symbolically with the mark of sin, but the fig leaf signifying their fall ultimately is worn by the eyes of the beholder.

Mann's pictures make both Christian fundamentalists and right-thinking feminists uncomfortable. Four years ago, at a discussion in San Francisco sponsored by The Friends of Photography, Barbara DeGenevieve (herself a photographer no stranger to controversy) confronted Mann with iron-clad pictorial evidence linking her pictures to a tradition of representation that eroticized children's bodies and thus heightened male desire. DeGenevieve showed slides of Charles

Dodgson's pictures of little Alice Liddell, Calvin Klein ads, and Jock Sturges' portraits of pubescent French nudists. But faced with the proximate presence of Sally Mann, and the spontaneous and stirring testimony of Mann's daughter, Jessie, DeGenevieve was moved to concede that the photographer's status as mother of her subjects relieved her work of the taint of base intention.

Intention, however, has nothing to do with what makes Mann's photographs so powerful and disturbing. Our own uneasy spectatorship does. We are the ones made nervous by the suspicion that pedophiles will take pleasure in Mann's pictures. We live in the post-edenic world that Mann's pictures implicitly critique; we see shame and naïvete through the guilty lens of scopophilia. No wonder Mann's pictures make us squirm: they are reminders of how far we have fallen.

Nevertheless, Mann's pictures throughout the 1990s increasingly suggest that she is acutely aware of the controversy her work has engendered, and specifically of the burdens of representation that her children, by being subjects, unavoidably assume. Indeed,

they are frequently shown embedded in a world of prior representation, impinged on by images from art history, popular magazines, and their own reflections. As they grow older and the photographer grows more self-conscious, the edenic spell seems about to lose its grasp. A mirror performs its reflexive doubling, allowing us to recognize that Mann's picture-making, like her elder daughter, is coming of age.

Mann's work does not wear the in-your-face demeanor that has made Mapplethorpe and Serrano names to be reckoned with in the halls of Congress. Still, it has the audacity to insist on its own expressive right to represent a rite of passage. It may be Victorian in sentiment, and it surely is resolutely, old-fashionedly Romantic in nature, but Mann's photography is twentieth-century brazen enough to ask us to shed the scales of our own skepticism about the possibility of innocent experience. If we think that this is immoral, then we can be proud to have invented a new morality based on cynicism and suspicion. ☿
—Andy Grundberg

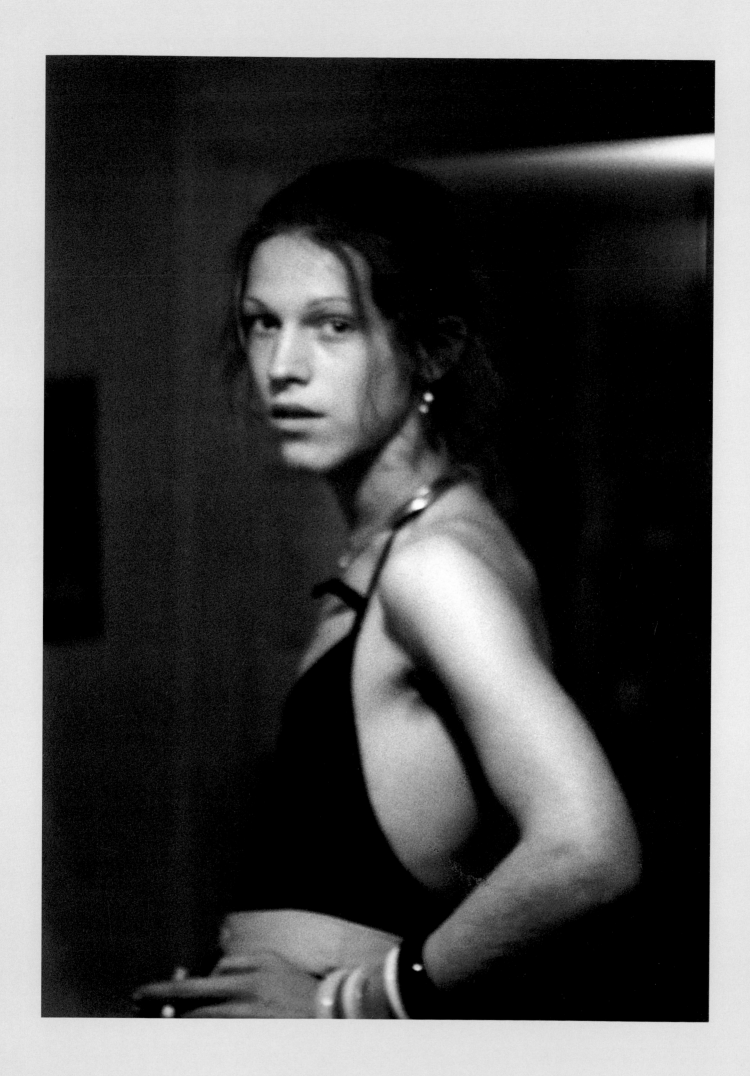

The Hill was Alive

In 1972, when I was 24 years old, I lived in Boston on the back of Beacon Hill. David Armstrong, the photographer and frequent subject of Nan Goldin's photographs, lived nearby, and I remember that when I first saw him he struck me as both different from anything I had ever known and the most beautiful creature I had ever seen.

BY DAVID BONETTI

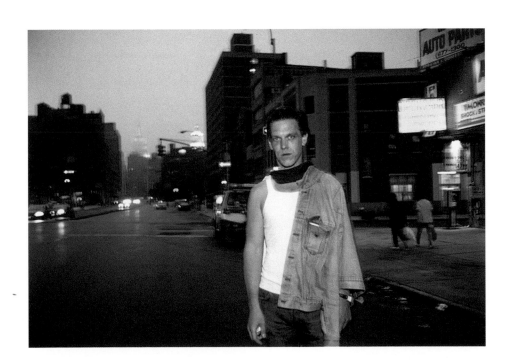

David on the Bowery, NYC, **1991.**

Facing page: *David at Grove Street, Boston,* **1972.**

Photographs courtesy Fraenkel Gallery, San Francisco.

I have never formally met David Armstrong. I have never spoken to him. But he plays a large part in the memories of my youth, as if he had been a close friend, or even a lover. I was fascinated by him, entranced by his androgynous beauty, and I *watched* him as often as I could, which was easy in our neighborhood community. The Hill, as we called it, was small and in those days divided between the respectable old-Boston Brahmin front slope and a Bohemian back slope so different that it might have been on a different continent. (Now, alas, it's mostly populated by yuppies and parvenus.) Charles Street, the shopping street and main drag, was common ground. The Hill was a village, and, being fellow villagers, I saw David Armstrong practically every day, practically every time I left my apartment.

I have one image of David Armstrong in mind that is as indelible as a photograph. It is a beautiful late-spring afternoon. (Spring comes late in Boston, but when it does come it is almost obscenely beautiful, sensually full-blown in a way no puritan city should allow.) In my memory, David Armstrong and his friend, identified as "Roommate" or "Bea" in Goldin's photographs, are standing on a stretch of sidewalk in front of the Charles Street Meeting-house at the corner of Charles and Mt. Vernon Streets, the latter of which Henry James once described as the most respectable street in America. They both are young and beautiful. David Armstrong is pale and blonde. Bea's skin is café au lait, a term used at that time to describe light-skinned black people. They are both tall and thin, and they are glamorous as only tall, thin and poor people with chic can be.

In my memory, David Armstrong and Bea are standing so close they seem joined at the waist. Both are wearing diaphanous, flowing dresses over their jeans. The gentle wind blows their garments and their long hair—Bea's tied loosely around her head—in slow motion. The sun, shining on the Charles River, gilds their hair with back-lighting. They laugh extravagantly, all elbows and attitude. Bea throws her head back and laughs long and silently. David Armstrong giggles. Together, they presented an image I shall never forget of a perfect world that existed only during a few delirious springs on Beacon Hill and on a few

other such islands of beatitude sprinkled across this surly land.

Okay, time has burnished this image in my mind, altering facts and proving that memory has its flaws. When Goldin's book, *The Other Side,* was published in 1993, I was shocked to discover that David Armstrong was not blonde in 1972, but rather had light-brown hair. Similarly, sometimes when I press my memory of that golden moment of distant youth and endless possibility, I see him and Bea at the corner of Charles and Beacon Streets, across from the Public Garden. In other instances of hazy recall, they appear outside Phillips Drugstore, where Charles Street turns into the meanness of Cambridge Street.

Once I doubt myself, more questions follow: Were they wearing dresses or blouses? Jeans or bell-bottoms? What about their shoes? Were they wearing high-heel clogs, or did those not come into fashion until later in the 1970s? (I can never accurately remember the chronology of styles.) When doubts overwhelm my memory, I see that David Armstrong is the one who throws his head back and laughs, and that Bea is the one who giggles. At other times, this vision that haunts my memory takes place not during that brief and precious spring, but in autumn. Following these doubts and worries, I eventually relax. If my feelings about this memory are accurate—and they are—then the details are not so important.

Who ever expects, however, to find their memories corrected by the publishers of art books? Usually, all you have are some snapshots, although my few from that time were lost in a fire. Who expects evidence or proof some twenty years later, particularly in the unlikely form of a book of artist's photographs?

But there it is. *The Other Side,* Goldin's book of portraits of the drag queens she has known and loved through the years, opens with "David at Grove Street, Boston, 1972," an image of David Armstrong that now overshadows my own best memory of him. In this photograph, he is the personification of loveliness. His face is perfect. Wisps of brown—not blonde—hair fall loose across his cheek. His mouth is just barely open. He looks back at the photographer with total openness. He is thin as only the blessed are thin. He stands with his hand on his hip in what used to be called, I believe, the

Smith slouch. He wears a skimpy halter top that exposes both back and belly. Dangling earrings, a necklace and an arm-load of bracelets reflect the light. He is a creature *between.* Between innocence and experience, male and female, child and adult. He is the type of evanescent beauty that Aubrey Beardsley or F. Holland Day would have recognized and idolized, turned into art, as Goldin has.

In this photograph, and in many others included in the series of remarkable books that Goldin has published over the last decade, I have recovered more than just my memory (now corrected) of David Armstrong. Indeed, I have recovered part of that time in my life during which I discovered and defined who I was, and laid out, for better or worse, the outlines of my future.

Nan Goldin and her friends, Beacon Hill's young drag queens who helped to create a mode of image transgression now called gender fuck, were not my friends. My friends from that period tell a different—but I suppose equally characteristic—story. Most of them, like Goldin's, now are dead or scattered. Goldin's clique and mine inhabited the same territory, however. Our paths overlapped daily. I'm sure we all had friends on Revere Street. *Everyone* had friends on Revere Street. (The names of those streets on the Hill now loom with legendary import in my safer, more respectable and infinitely more boring life.)

My friends and hers went to The Other Side, the Bay Village Mafia bar that catered to drag queens. The bar was my first intimate acquaintance with the real danger inherent in being different. We all summered in Provincetown, P-Town, the self-proclaimed "Last Resort" that was indeed the last resort for more than one young aspiring queen. Still, I remember that you could go there with a five-dollar bill in your pocket and return a week later without having had to touch it.

The first time I saw a Nan Goldin photograph that brought this era back for me was in her first, now-classic book, *The Ballad of Sexual Dependency.* Most of those pictures were taken during the late '70s and early '80s, after Goldin and several of her friends fled Boston for New York City to play among a larger field of like-minded people. The book does,

however, include several images from her Boston days. One, "Picnic on the Esplanade, Boston, 1973," startled me. It is a picture of a party on the banks of the Charles River, and it includes all of her group's central members: Bea and David Armstrong and Tom Chesley and Ivy (wearing a pretty flowered dress) and a woman turning her head away that might be Goldin herself.

When I first saw it, the picture looked familiar, *too* familiar. Then I remembered: I'd walked by that party more than a dozen years before. I'd looked down from the path onto the revelers, and in the special kind of loneliness one has when one is 25 years old and cruising the Esplanade, I wished that I was sitting there enjoying their yellow store-bought cake with them. Wandering as I was in solitude, their gathering seemed at once enticing and forbidden. If I couldn't be celebrating something wonderful with my own friends, or with a new friend met only minutes before who was certain to be the love of my life, then why not join Goldin's picnic? I didn't, of course, but the photograph brought back that scene I had glimpsed with incredible vividness and immediacy.

In subsequent years, I got used to Goldin's images delivering jolts of recognition, whether they were of people I knew (if only from a distance) or of total strangers. The jolts occurred because her photographs were true. They offered accurate testimony of a way of life many had struggled through and not all survived. They were brave and loving and heartbreaking all at once. I was particularly excited when I heard that she was going to publish *The Other Side.* I had hung out in that club on and off for a number of years, and had fond and lurid memories of it. Would her images demolish my memories as falsified nostalgia, or would she bring back my memories more fully than I remembered them?

When the book came out, I immediately was relieved not to be caught in the background of a shot, sporting one of the hideous hairstyles popular during that era. But then I was disappointed: the entire book wasn't devoted to the Other Side that I knew from Boston. It started there, but then it traveled

Picnic on the Esplanade, Boston, 1973.

I'd looked down from the path onto the revelers, and in the special kind of loneliness one has when one is 25 years old and cruising the Esplanade, I wished that I was sitting there enjoying their yellow store-bought cake with them.

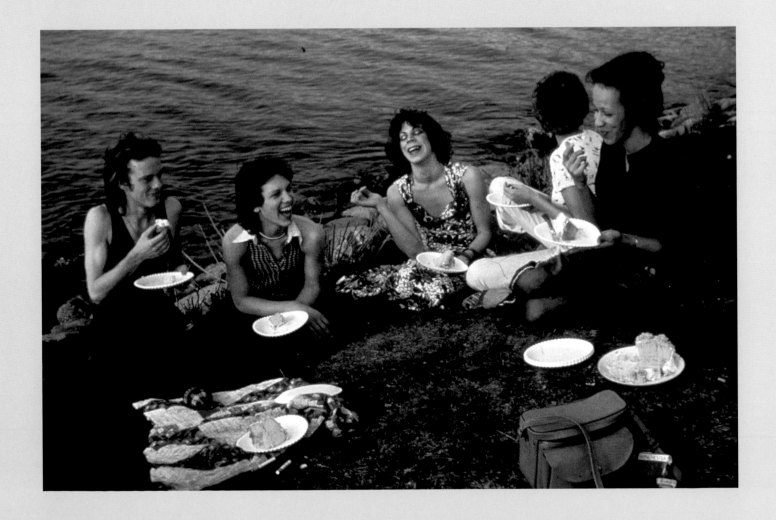

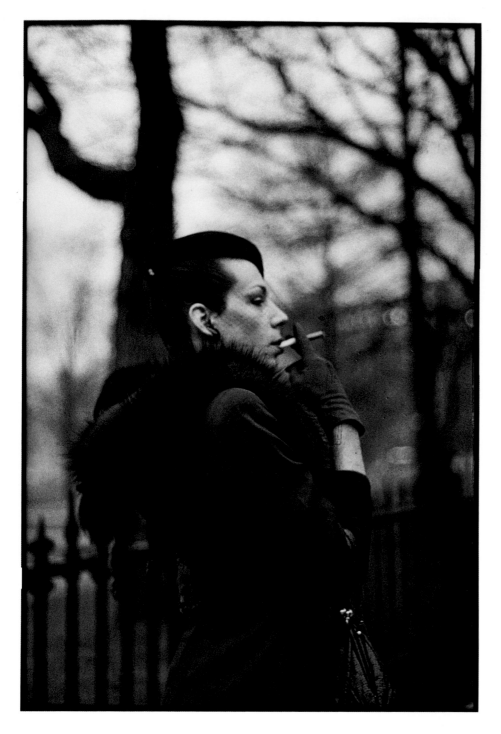

Marlene and Ivy, wherever they are, whatever they are twenty-odd years later, have, thanks to Goldin, joined *Vogue*'s models in the history of style and glamour. These photographs will have to be shown alongside classic images of Jean Shrimpton, Penelope Tree and Verushka so that future generations will understand how much those in the sexual underground challenged all notions of identity and self-expression during the heady years of the 1970s.

What was it about drag and gender fuck in those days? The world was just emerging from a long nightmare of depression, war and repression that had dominated much of the century. Was drag a symbol of freedom, of the desire to remake the world in one's own image, often according to an impossible ideal? Was it, in a political sense, a brave statement of refusal to accept the status given to us at birth? Perhaps it was, and remains, a reminder of the struggles and rewards of self-invention.

In her introduction to *The Other Side*, Goldin reminisces that when she first saw Ivy and Naomi and Colette, she was struck with the fact that "they were the most gorgeous creatures I'd ever seen"—an admission uncannily close to my own recollection of my early appreciation of David Armstrong. He was, alas, a perfect beauty for only a season or two. In our lives, beauty comes and then it is gone. In the introduction to *A Double Life*, a 1994 book that pairs images by Goldin and Armstrong, he bravely tells his own story of his addictions and the battles he waged against them, hitting bottom again and again. Goldin's pictures of him, honest and loving, document his descent and his return.

Still, he was perfect once, and I will remember him that way forever—whether his hair was blonde or light-brown, it doesn't really matter—thanks to Nan Goldin's pictures and the imperfect function of my imperfect memory. ☿

outward, to New York, Berlin, Paris, Manila and Bangkok. I eventually realized that Goldin had found the right balance, and that The Other Side was presented in a better light than it, or I, had any right to expect. It was, after all, a tawdry place, a place of dubious importance where society's losers came together to pretend they were as grand as their paltry fantasies.

The photographs in *The Other Side* remind me of how beautiful the queens were. The faces that I remember now have names, and for the first time I get to see them at home. Marlene is the most elegant. In the two pic-

tures Goldin printed of her competing at the weekly Beauty Parade, she is a vision of such perfect elegance that Goldin's oft-stated goal of putting queens on the cover of *Vogue* makes perfect sense. But Ivy! She takes the prize for brazen defiance of gender roles and inventive

Was drag a symbol of freedom, of the desire to remake the world in one's own image, often according to an impossible ideal?

re-creation of self, especially in two pictures of her walking across the wintry Public Garden in a tailored suit, fur stole and hat, smoking a cigarette like a star from a '40s movie.

Ivy in the Boston Garden: back, Boston, 1973.

Facing page: Ivy in the Boston Garden, Boston, 1973.

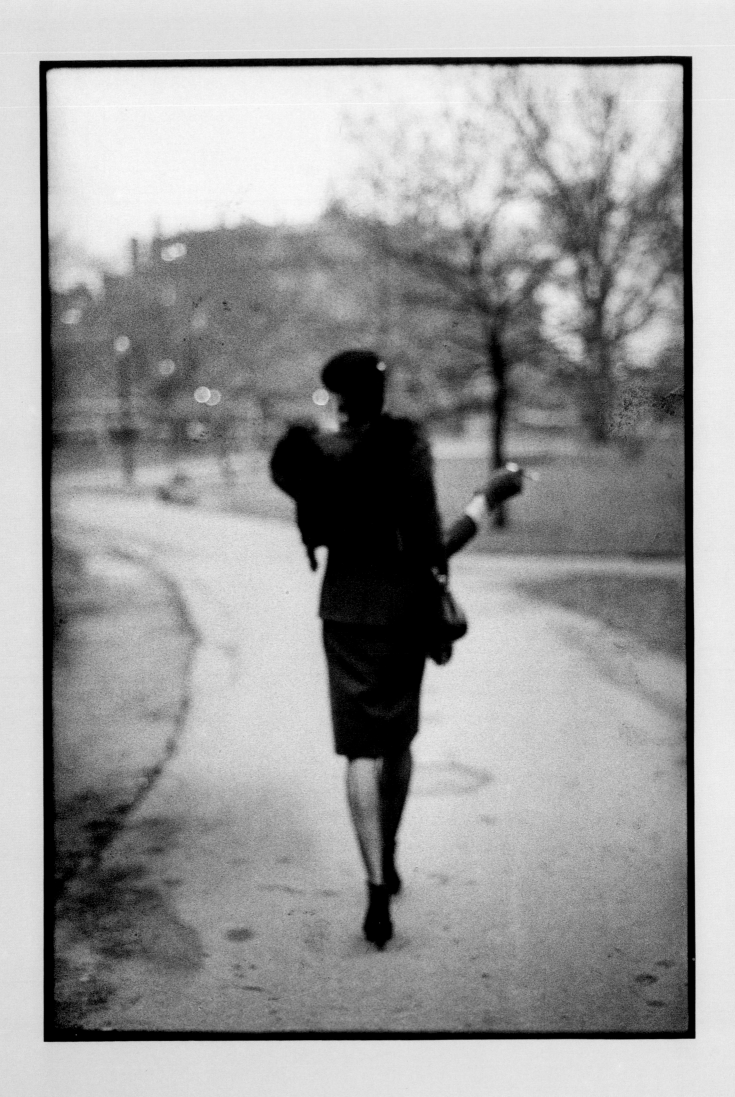

HARRY CROSBY, FROM A DIARY ENTRY, JULY 5, 1928.

LEARNED THINGS ABOUT THE SUN: THAT THE ANCIENTS BELIEVED THAT THE SUN AND EARTH WERE CONNECTED BY A CHAIN (OMBILICAL?); THAT THE ANCIENT EGYPTIANS CALLED THE SUN THE CAT BECAUSE THE PUPIL OF THE CAT'S EYE GROWS LARGER WITH THE ADVANCE OF THE DAY (THE EGYPTIANS IMAGINED THAT A GREAT CAT STOOD BEHIND THE SUN

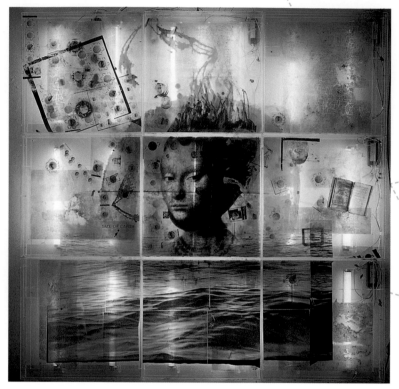

Mike and Doug Starn, *Take Off Your Skin*, 1990–94.

WHICH WAS THE PUPIL OF THE CAT'S EYE); THAT EGYPTIAN SUN-WORSHIP INCLUDED A WORSHIP OF THE ACTUAL DISK OF THE SUN; THAT EVERY WHEEL HAS THROUGHOUT THE AGES SYMBOLIZED THE SUN; THAT EVERY MORNING THE BRAHMANS MAY BE SEEN FACING THE EAST, STANDING ON ONE FOOT AND STRETCHING OUT THEIR HANDS TO THE SUN; THAT IN LUCIEN'S TIME THE GREEKS KISSED THEIR HANDS AS AN ACT OF WORSHIP TO THE RISING SUN; THAT THE EMBLEM OF THE JAPANESE SUN-GODDESS WAS THE MIRROR; THAT IN PERU A CERTAIN RELATIONSHIP WAS THOUGHT TO EXIST BETWEEN THE SUBSTANCE OF GOLD AND THAT OF THE SUN ("IN THE NUGGETS DISLODGED FROM THE MOUNTAIN SIDES THEY THOUGHT THEY SAW THE SUN'S TEARS"); THAT HUMAN SACRIFICES TO THE SUN WERE COMMON IN PERU; THAT THE IROQUOIS REGARDED THE SUN AS A GOD AND OFFERED HIM TOBACCO WHICH THEY TERMED "SMOKING THE SUN"; THAT IN THE COURSE OF THEIR SERVICE OF SUN-WORSHIP THE APALACHEES RELEASED THE SACRED SUN-BIRDS THROUGH A CREVICE IN THE ROOF OF THE CAVETEMPLE AND THAT THESE AS THEY WINGED THEIR WAY UPWARD WERE THOUGHT TO CONVEY THEIR EXPRESSIONS OF ADORATION TO THE SUN; THAT OF ALL THE INDIAN CUSTOMS AND FORMS OF WORSHIP OF SOLAR SIGNIFICANCE THE GREAT CEREMONIAL OF THE SUN-DANCE BEST EXEMPLIFIED THE WORSHIP OF THE SUN; THAT TO MAKE THE SUN GO FASTER THE AUSTRALIANS THROW INTO THE AIR AND BLOW WITH THEIR MOUTHS TOWARDS THE SUN (THE INDIANS USED TO PULL OUT THEIR EYELASHES AND BLOW THEM TOWARDS THE SUN); THAT CHRISTMAS IS NOTHING BUT AN OLD HEATHEN CELEBRATION OF THE WINTER SOLSTICE; THAT SUN-MASKS WERE A PROMINENT FEATURE IN THE SOLAR CEREMONIALS OF MANY OF THE INDIAN TRIBES; THAT THE RED COLORS AT SUNSET ARE CAUSED BY THE BLOOD FLOWING FROM THE SUN-GOD WHEN HE HASTENS TO HIS SUICIDE (31-10-42) [THE DATE HARRY CROSBY

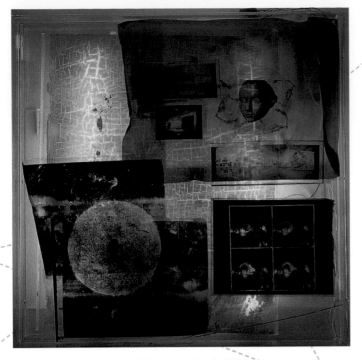

Mike and Doug Starn, detail from *Gut Epoch*, 1990–94.

AND HIS WIFE, CARESSE, PLANNED TO DIE TOGETHER. THAT SAME DATE, EARTH REACHED ITS PERIHELION, THE POINT IN THE PATH OF A CELESTIAL BODY THAT IS NEAREST TO THE SUN.]; THAT THE SUN WAS REGARDED BY THE GREEKS AS THE SYMBOL OF PERFECT BEAUTY AND THAT THEY FORMERLY PAINTED THE SUN'S DISK ON THE CHEEKS OF THE BRIDE; THAT IT SEEMS TO HAVE BEEN AN ALMOST UNIVERSAL BELIEF AMONG PRIMITIVE PEOPLE THAT THE SUN AND MOON WERE THE ABODES OF DEPARTED SOULS; THAT THE APPEARANCE OF THREE SUNS DENOTES WAR AND THAT THESE THREE SUNS APPEARED JUST BEFORE NAPOLEON'S DISASTROUS CAMPAIGN IN RUSSIA; THAT MEXICANS HAVE A BELIEF THAT BLONDES CANNOT SEE THE SUN; THAT TO DREAM THE SUN SHINES MEANS SUCCESS TO THE LOVERS; THAT THE STONES AT STONE-HENGE WERE SO ARRANGED THAT AT SUNRISE AT THE SUMMER SOLSTICE THE SHADOW OF THE STONE FELL EXACTLY ON THE STONE IN THE CENTRE OF THE CIRCLE INDICATING TO THE PRIEST THAT THE NEW YEAR HAD BEGUN; THAT IN THE BOOK OF THE DEAD THE SUN IS OFTEN REPRESENTED AS AN EYE PROVIDED WITH WINGS AND FEET; THAT THE HAWK WAS DEDICATED TO THE SUN AND THAT THE LION WAS A SYMBOL OF THE SUN; THAT THE CROSS SYMBOL OF THE CHRISTIAN FAITH IS A SYMBOL THAT ANTEDATED THE BIRTH OF CHRIST AND ONE THAT FOUND ITS ORIGIN IN SOLAR WORSHIP; THAT IN SOLAR SYMBOLISM THERE ARE RULES WHICH CONNECT THE SUN WITH GOLD, WITH HELIOTROPE, WITH THE COCK WHICH HERALDS DAY, WITH MAGNANIMOUS ANIMALS SUCH AS THE LION AND THE BULL; THAT THE RATE OF SPEED MAINTAINED BY THE SUN IS ESTIMATED AT FROM TEN TO TWELVE MILES A SECOND; THAT 92,930,000 MILES IS THE SUN'S DISTANCE FROM THE EARTH; THAT NO FEWER THAN ONE HALF A MILLION OF FULL MOONS SHINING ALL AT ONCE WOULD BE REQUIRED TO MAKE UP A MASS OF LIGHT EQUAL TO THAT OF THE SUN.

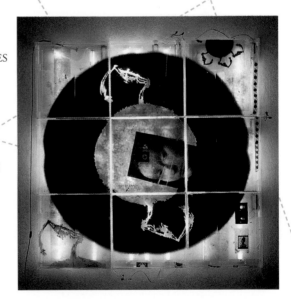

Mike and Doug Starn, *Some Saint's Fingernail*, 1990–94.

O P E N S P A C E , a regular feature of see, provides a blank canvas for artists involved with the photo novella, image/text works, artist's books and other means of presentation that defy classification. Each project is conceived specifically for these pages; participating artists are confined only by the size and shape of the journal. For this issue, the following eight pages belong to Mike and Doug Starn.

Mike and Doug Starn

...because my sight, becoming pure, was able
to penetrate the ray of light more deeply—
that light, sublime, which in itself is true.
 From that point on, what I could see was greater
than speech can show: at such a sight it fails—
 and memory fails when faced with such excess.
 As one who sees within a dream, and, later
the passion that had been imprinted stays,
but nothing of the rest returns to mind,
 such am I, for my vision almost fades
 completely...

Dante, *Paradise*, Canto XXXIII 52–62
Translation by Allen Mandelbaum, Bantam Classics

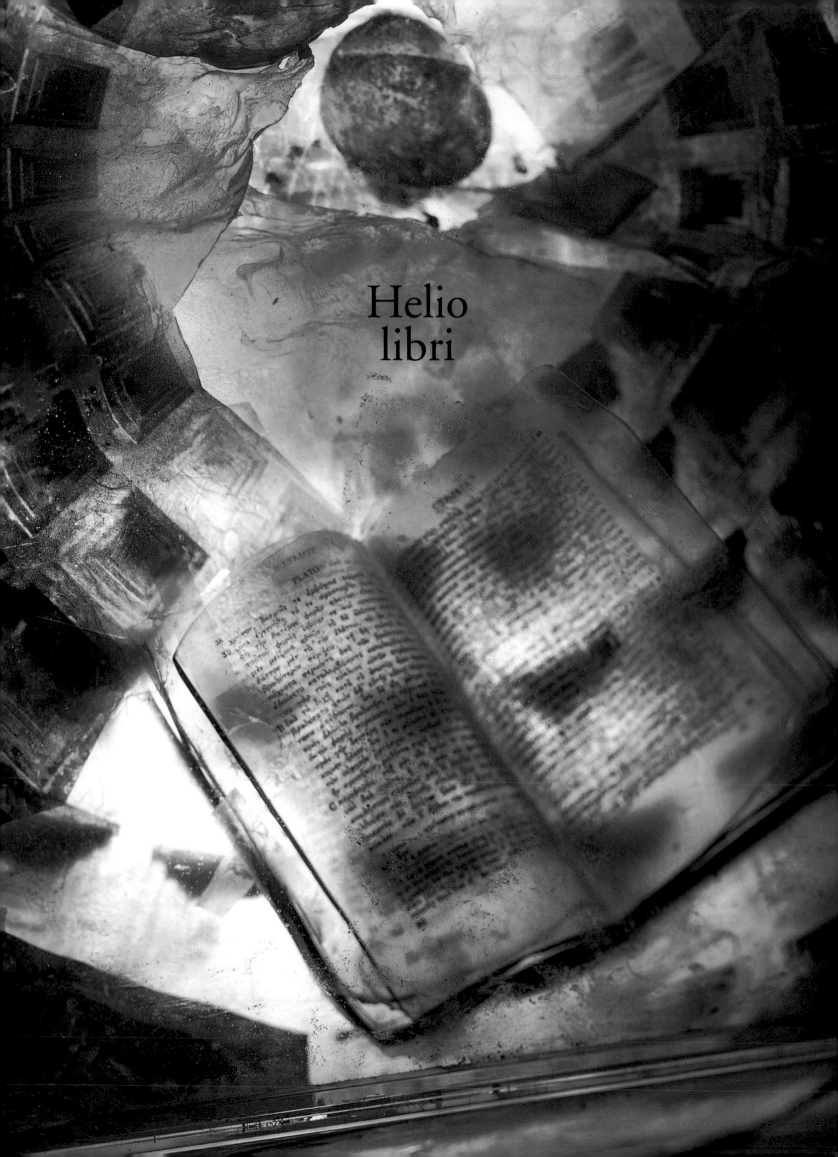

Helio
libri

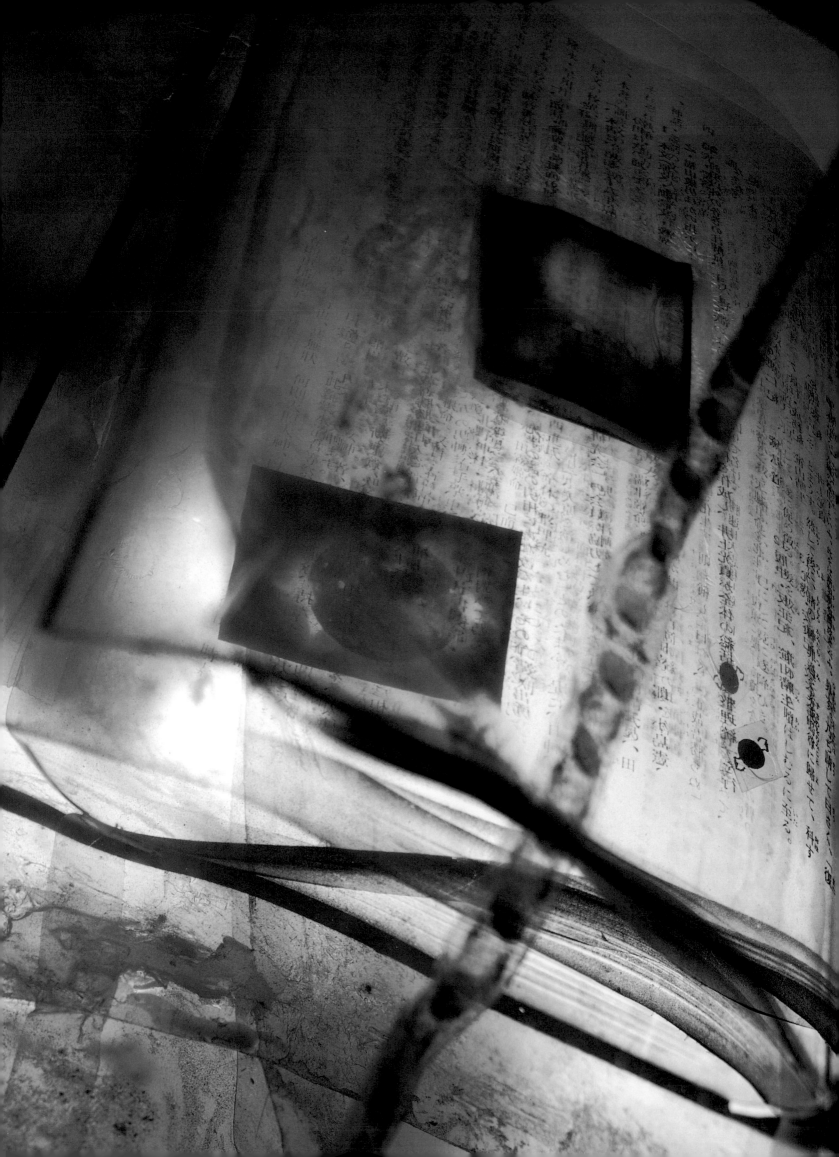

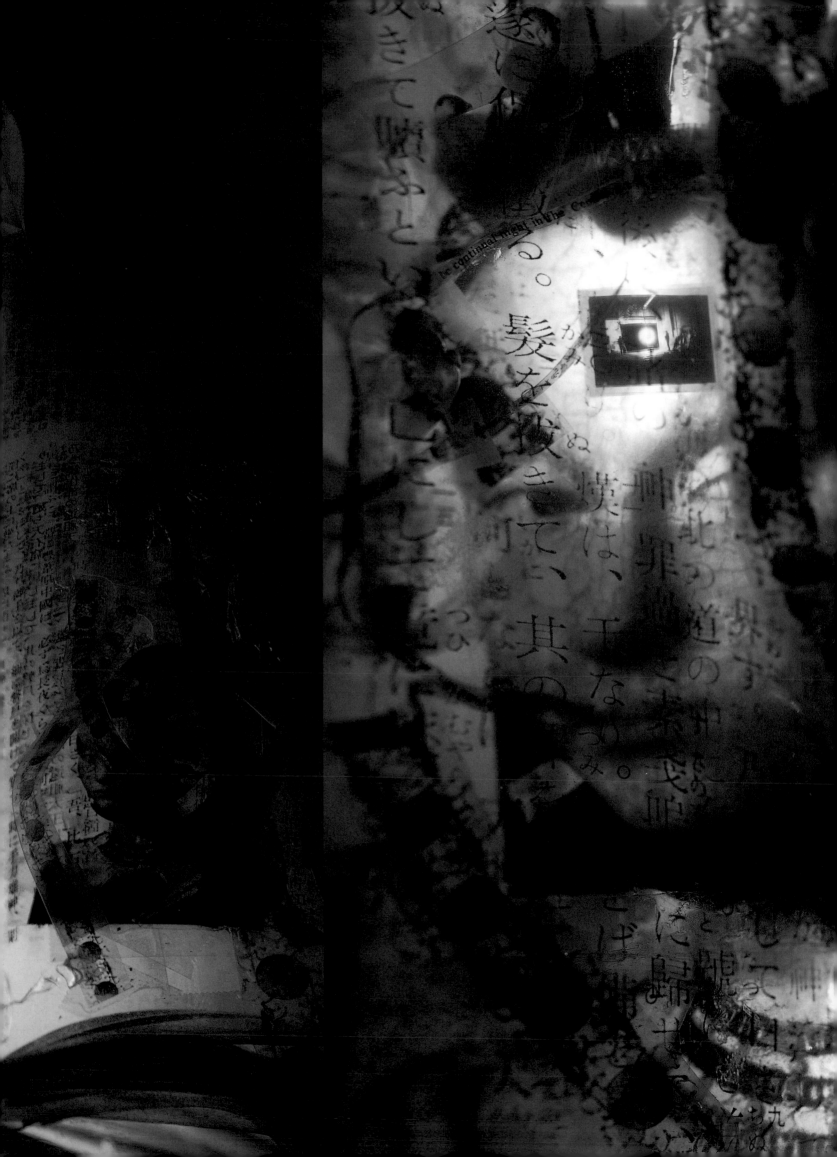

10 mi. 14,
30 mi. 40.

mi. 25
14 m.
gra. 43 mi.

Latitudo...
Locus...
Declinatio...
Ascensio...
Mediat coelum hora 1 mi. 55
Amplitudo ortus & occasus gra...
Distantia cometæ à Sole 18 gra.
Occasus cometa hora 8 mi. 50
Oritur cometa hora 6 mi. 52

Status cometæ in parte occidentis. Status cometæ...

SEPT HORIZON

RADIX SOLIS

TERTIO AVGVSTICO.

11 mi. 26
occasu gra. 3 mi. 5

Iudeburgum

Iucatan
Pera

EARTH

seebooks

The Friends of Photography Bookstore
250 Fourth Street, San Francisco CA 94103
415.495.7242 Fax 415.495.8517

The Friends of Photography Bookstore is an invaluable resource for photography-inclined bibliophiles who would like the finest new photography titles delivered straight to their door. Following is a choice selection of new books for Fall, 1995. Use the form on the facing page to place your order.

Raised by Wolves. Photographs by Jim Goldberg. Scalo Publishers in association with the Corcoran Gallery of Art and the Addison Gallery of American Art, 1995. 320 pages, 45 four-color reproductions, 198 duotones. $45 softbound, **special price $40.50.** In *Raised by Wolves,* Jim Goldberg brings together his pensive documentary photographs with found images and snatches of hand-written, often poetic passages that his subjects have composed about their lives and feelings. This sweeping documentary project about teenage runaways in San Francisco and Los Angeles confounds tired generalizations about homeless people in America. Goldberg's brave, vital book speaks to the young and "at risk," and to those who want to understand them. **DUE SEPTEMBER.**

Walker Evans: A Catalogue of the Collection. Text by Judith Keller. J. Paul Getty Museum, 1995. 416 pages, 31 four-color reproductions, 1054 duotones. $95 clothbound, **special price $85.50.** *Walker Evans: A Catalogue of the Collection* brings together the entire Evans collection of the J. Paul Getty Museum—nearly 1200 images—in the closest work yet to a *catalogue raisonne* for this icon of American photography. Judith Keller's lively text provides essential background on the major phases of Evans' artistic development. In the wealth of biographical and bibliographical information assembled here—including the most extensive Evans bibliography yet compiled—even readers who are well-acquainted with Evans work will find much that is new. **DUE LATE OCTOBER.**

Tina Modotti: Photographs. Text by Sarah M. Lowe. Abrams, 1995. 160 pages, 148 duotones, bibliography, notes. $45 cloth-bound, **special price $40.50.** In the last decade, the powerful work and dramatic life of Italian-born photographer and Marxist revolutionary Tina Modotti have become subjects of intense interest. This richly illustrated book, the first comprehensive study of Modotti's photographs, also is the catalogue for the first retrospective exhibition of her work. This beautiful monograph features an enlightening text by Sarah M. Lowe. **DUE SEPTEMBER.**

Edward Weston: Forms of Passion. Edited by Gilles Mora, with essays by Gilles Mora, Terence Pitts, Trudy Wilner Stack, Ted Stebbins and Alan Trachtenberg. Abrams, 1995. 368 pages, 320 duotones, bibliography, chronology, list of exhibitions, index. $65 clothbound, **special price $58.50.** Called "the founding father of American photography" by photography historian Beaumont Newhall, Weston forged a modernist style that dominated American photography for the first half of the twentieth century. This new volume, the most comprehensive survey available of Weston's work, includes more than three hundred exquisitely reproduced duotone reproductions. **DUE OCTOBER.**

Joel-Peter Witkin: A Retrospective. Edited by Germano Celant. Scalo Publishers, 1995. 224 pages, 100 quadtones. $60 clothbound, **special price $54.** This handsome volume surveys Witkin's career from its very beginnings through the present day, bringing together for the first time almost one hundred of his photographs. Germano Celant, curator at the Guggenheim Museum, has contributed a thoughtful essay on the significance of this controversial artist's work. **DUE SEPTEMBER.**

Michael Kenna: A Twenty Year Retrospective. Foreword by Ruth Bernhard, essay by Peter Bunnell. In English and Japanese. Treville Co., Ltd., Tokyo, 1995. 150 pages, 130 duotones. $65 clothbound, **special price $58.50.** This gorgeous retrospective monograph of Michael Kenna's work brings together many celebrated images with many lesser-known and never-before-published works. The high-quality reproductions are complemented by Peter Bunnell's insightful text and Ruth Bernhard's moving foreword. **A LIMITED NUMBER OF SIGNED COPIES ARE AVAILABLE NOW!**

Nouvelle Histoire de la Photographie. Edited by Michel Frizot. Bordas Publishers, France, 1994. In French. 776 pages, 117 halftones, 786 duotones and 148 color reproductions. $325 clothbound, slipcased, **special price $292.50.** The most current history of photography to date, *Nouvelle Histoire* contains over one thousand beautiful reproductions from photography's beginnings to the present day. This is an exquisite cloth-bound, slipcased book, finely printed with text by an international group of scholars and complete bibliography. A must for collectors, dealers and scholars! *Text in French.* **LIMITED QUANTITIES!**

Lengthening Shadows Before Nightfall. Photographs by John Dugdale. Twelvetrees Press, 1995. 104 pages, 68 color reproductions. $45 clothbound, **special price $40.50.** In an interplay of metaphor and time, artist John Dugdale invokes a world of transgression, captured in a web of light-filled chambers and sensuous bodies. Using the non-silver cyanotype process, Dugdale's imagery emerges in a mist of loss and remembrance, melancholy and nostalgic *ennui.* **DUE OCTOBER.**

books

must have

250 Fourth Street, San Francisco, CA 94103 415.495.7242 Fax 415.495.8517 e-mail: FOPbooks@aol.com

Quantity		(Regular Price)	Subscriber's Price	Amount
_____	*Jim Goldberg: Raised by Wolves*	($45.00 paper)	$40.50	_____
_____	*Walker Evans: A Catalogue of the Collection*	($95.00 cloth)	$85.50	_____
_____	*Tina Modotti: Photographs*	($45.00 cloth)	$40.50	_____
_____	*Edward Weston: Forms of Passion*	($65.00 cloth)	$58.50	_____
_____	*Joel-Peter Witkin: A Retrospective*	($60.00 cloth)	$54.00	_____
_____	*Michael Kenna: A Twenty Year Retrospective*	($65.00 cloth)	$58.50	_____
_____	*Nouvelle Histoire de la Photographie*	($325.00 cloth)	$292.50	_____
_____	*Lengthening Shadows Before Nightfall, Photographs by John Dugdale*	($45.00 cloth)	$40.50.	_____

In Calif. please add applicable sales tax (8.5%). Shipping and handling charges: Continental U.S., per destination: via UPS, allow 2-4 weeks for delivery. $6 for first book, $1 for each additional title. Foreign, per destination: via surface mail, allow 6-12 weeks for delivery. $10 for first book, $2 each additional title.

Subtotal	_____
Sales Tax	_____
Shipping	_____
Total	_____

Ship to:

Name _____

Street Address _____

City/State/Zip _____

Telephone _____

Subscriber/Member # _____

Payment

_____ My check is enclosed (U.S. funds, foreign remittance by International Postal Money Order only)

Please charge to my credit card VISA Mastercard AmEx

Amount charged _____

Card number _____ Exp.Date _____

Signature _____

stamp me!

The Friends of Photography
250 Fourth Street
San Francisco, CA 94103

stamp me good!

The Friends of Photography
250 Fourth Street
San Francisco, CA 94103

Send to:
The Friends of Photography Bookstore
250 Fourth Street
San Francisco, CA 94103

Feast my eyes!
Start my one year membership in The Friends of Photography immediately, so that I'll get see and enjoy all the benefits of membership described at left.

Please choose membership level (includes subscription to see):
___ $60 Associate ___ $300 Sustaining
___ $75 Family ___ $600 Contributing
___ $80 Foreign ___ $1,200 Patron
___ $125 Supporting ___ $2,500 Benefactor ___ Please bill me.

___ Please send me a one year subscription to see for $48. I am not interested in becoming a member of The Friends of Photography at this time.

___ Please send me more information about The Friends' Collector Print Program.

Name(s) —————————————————————————

Address —————————————————————————

City ———————————————— State ———— Zip ————

Phone ———————— Fax ———————— E-mail ————————

For faster service, contact us to charge your order.
Phone: 415.495.7000 Fax: 415.495.8517 E-Mail: see fop@aol.com

Feast my eyes!
Start my one year membership in The Friends of Photography immediately, so that I'll get see and enjoy all the benefits of membership described at left.

Please choose membership level (includes subscription to see):
___ $60 Associate ___ $300 Sustaining
___ $75 Family ___ $600 Contributing
___ $80 Foreign ___ $1,200 Patron
___ $125 Supporting ___ $2,500 Benefactor ___ Please bill me.

___ Please send me a one year subscription to see for $48. I am not interested in becoming a member of The Friends of Photography at this time.

___ Please send me more information about The Friends' Collector Print Program.

Name(s) —————————————————————————

Address —————————————————————————

City ———————————————— State ———— Zip ————

Phone ———————— Fax ———————— E-mail ————————

For faster service, contact us to charge your order.
Phone: 415.495.7000 Fax: 415.495.8517 E-Mail: see fop@aol.com

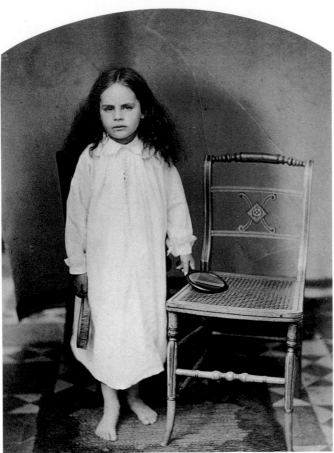

Lewis Carroll, *It Won't Come Smooth*, 1863. From *Pleasures Taken*.

PRINT IN

Pleasures Taken: Performances of Sexuality and Loss in Victorian Photographs
by Carol Mavor
Duke University Press, 1995

Review by Charles Malone

When I lived on the Lower East Side in New York, one of the first Spanish words I learned was *mira,* as in *mira, mira!* or *look, look!* Surrounded by families with young children, I noticed a social compulsion of parenthood: the desire to direct childrens' interest to aspects of the world that, in parental estimation, deserve attention. This common gesture of solicitude seems exemplary of parents' affectionate desire to reveal the world to their children, to offer up to them a sense of what is important, dangerous,

curious, beautiful, delightful. But just as surely there is an element of command and coercion in the insistent repetition to "look, look." To borrow a theme from Yi-Fu Tuan's excellent book, *Dominance and Affection,* the pleasure adults get from directing what children should look at (and *how* they should look) is a mixture of generosity and control.

The title of Carol Mavor's new book, *Pleasures Taken: Performances of Sexuality and Loss in Victorian Photographs,* embraces this tension between pleasures offered and pleasures taken. To a large extent, Mavor's text carries out the promise of this embrace by seducing us into finding pleasure in photographs that might otherwise make us feel uneasy. *Pleasures Taken* charismatically dramatizes the erotic and playful possibilities of a whole range of Victorian images. Under scrutiny are several

nineteenth-century images that have in recent years given pause to critics and historians, including Lewis Carroll's erotically charged pictures of young girls that, in Mavor's words "question the value of innocence"; Julia Margaret Cameron's quirky "Madonna" photographs that "enlarge our vision of the relationship that motherhood, sensuality, sexuality, and death share"; and, not least, the pictures and diaries of young Hannah Cullwick. The discussion of Cullwick exceeds previous accounts of her life as the young maid-of-all-trades and passive model for photographer Arthur Munby. Mavor reveals Cullwick as "a person who acted on and acted out desire"—a characteristic that Mavor herself embodies as she endeavors to take the risk out of acting out, or performing, her sensual experience of these photographs.

Mavor's primary contribution to photography criticism lies in her critique of what Martin Jay has called the "ocularcentric" interpretation of the world, in which sight is privileged above the other senses and epistemology is informed by spectatorship. Photography, it turns out, is not where the ocularcentric regime fully comes to power, but paradoxically is the site of its undoing. Building on contemporary French feminist Luce Irigaray's subversive reintroduction of the female body into philosophical thought, and the author's own willingness to allow her subjectivity to be "altered" by the caresses of another, Mavor explores how a criticism informed by touch can mock the defensive, rigid boundaries of the autonomous self. Giving up the ceaseless quest for mastery and control, Mavor endeavors to teach us how to blush again.

But is it okay to blush at a photograph like Lewis Carroll's "It Won't Come Smooth"? In this picture, a sultry little girl apparently has given up trying to brush her hair by herself; she seems to be asking for the help of more experienced hands, or at least permission to let her untamed locks be, even if it means going against the dictates of what is proper for a nice little girl. Mavor's encouragement to respond sensually to such

images begs a difficult question: is it truly possible to "acknowledge the sexuality of children" without "project[ing] our oppressive desires onto their bodies"?

Alice Miller, a psychoanalyst whose commitment to helping sexually abused children is beyond reproach, goes so far as to repudiate the Freudian notion of childhood sexuality altogether in her recent book, *Thou Shalt Not Be Aware: Society's Betrayal of the Child.* For Miller, such an outlook insidiously makes the child somehow complicitous with, and responsible for, the abuse suffered at the hands of adults. For Mavor, this is an unacceptable response to the problem of sexual abuse because it robs the child model of any sexual agency whatsoever and demonizes all expressions of adult sexuality in relation to children. Mavor's ability to identify both with Lewis Carroll (the "impish professor") and Alice Liddell (the "performative little girl") assuages our fears that "sexualizing" children is inevitably sick and perverse.

However, Mavor does at times avoid tough questions in her commitment to an innocent erotic play of differences. For instance, her eagerness to identify with Arthur Munby's maid, Hannah Cullwick, overreaches the disparity of their social positions and respective erotic performances.

Mavor has set her sights higher than an antiquarian study of Victorian photographs. She wants to situate these photographs in the midst of the contemporary discourses on how peoples' bodies become the subject of erotic attention. She gives a sense of these broader cultural issues when she notes that the "child and the photograph were commodified, fetishized, developed, alongside each another." This concern with how the economic, psychological and aesthetic function in relation to one another points to how our pleasures are caught up in the trafficking of certain kinds of pictures and erotic scripts. *Pleasures Taken: Performances of Sexuality and Loss in Victorian Photographs* opens up a netherplace where a mixture of passion and tenderness gives us good reason to put aside our suspicions and allow eros to emerge from unexpected places. ❦

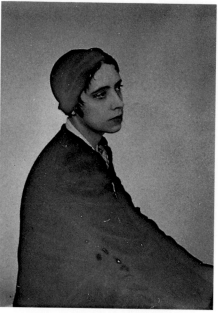

Secure the Shadow: Death and Photography in America
by Jay Ruby
MIT Press, 1995

Review by James Crump

All those young photographers who are at work in the world, determined upon the capture of actuality, do not know they are agents of Death.
—Roland Barthes, *Camera Lucida: Reflections on Photography*

The nature of photography's inextricable link with death has been a topic for debate since the medium's inception. As early as 1839, William Henry Fox Talbot spoke of photography's "[partaking] of the character of the marvelous." He wrote: "Such is the fact, that we may receive on paper the fleeting shadow, arrest it there and in the space of a single minute fix it there so firmly as to be no more capable of change..."[1] In Fox Talbot's desire to "secure the shadow," we see something of our own will to believe in the photograph's representation of life, even when it is Death staring squarely into our eyes.

Arguably, it is our inability to articulate the mysteries beyond life and the destination of the soul that has invested the photograph with authenticity, the trace of the real that Roland Barthes called the thing "that-has-been." As a referent to the past, the photograph has frozen time, embalmed it, as it were, in light-sensitive paper for those left behind. It gives a representation of the impression of life, one that never betrays its own future death or the spectator's eventual passing. The photograph has been a talisman of the living, breathing body, and never more so than when it takes note of our own mortality and transitory presence. Caught somewhere between life and death, the photograph has from the beginning offered an illusory retreat, a capsule of time suspended. And after decades of theoretical tracts interrogating its veracity, we still want to believe the image inscribed in its emulsion. As Barthes noted, "Contemporary with the withdrawal of

rites, Photography may correspond to the intrusion, in our modern society, of an asymbolic Death, outside of religion, outside of ritual, a kind of abrupt dive into literal Death." For Barthes, life and death are "reduced to a simple click, the one separating the initial pose from the final print."[2]

In *Secure the Shadow: Death and Photography in America*, a deceptively titled book on postmortem and memorial photography, author Jay Ruby underscores the currency of death and the recent embrace of the subject in academic circles. Ten years in development, Ruby's is a serious study, an anthropological accounting of the photographic artifact of death, and how society justifies its representation. It is not, however, the revisionist text it portends to be, nor the contextual antidote to the recent books that preceded it, most notably Barbara Norfleet's *Looking at Death* (1993) and Stanley Burns' modest tome *Sleeping Beauty: Memorial Photography in America* (1990). One immediately senses that Ruby has an ax to grind. Unfortunately, his private storm, brewing for more than a decade, seems to date his text, to have marooned it on a desert isle while the discourse on photography steadfastly progressed under the aegis of other scholarly disciplines. According to Ruby, his "...is an alternative to the *dominant* attitude which argues that photography is best understood as a form of fine art.... *Art historians argue that the vast majority of photographs are not worth seeing, let alone studying.* Social historians suggest that any photograph, provided there is some contextual information accompanying it, can reveal something interesting about the people who made and use it" [italics added].

Ruby's eulogy is late in coming—it can be argued that art history as a viable field is dead, supplanted by an interdisciplinary approach to interpreting images we now call "cultural studies." This doesn't prevent Ruby from divisively haranguing his image-literate brethren in "mainstream art history." While he boasts of the logic in studying photographs "with the methods of anthropology,

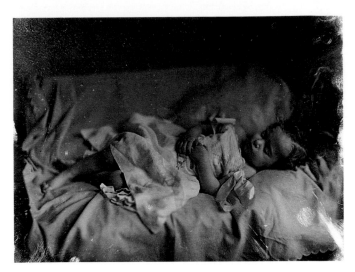

Southworth & Hawes, *Postmortem photograph of unidentified child,* ca. 1850s. Courtesy George Eastman House. From *Secure the Shadow.*

social history, and ethnography," his efforts reinforce the classic art historical paradigms of assigning meaning, quantifying, typing and categorizing—a positivist approach guised with the jargon of high academic prose.

Secure the Shadow seeks to offer alternatives for understanding the postmortem and memorial photograph. However, I would hesitate to posit how distinct this study is from its object-oriented, art-historical predecessors. In chapter one, for example, Ruby begins with a careful explication of the postmortem photograph's art-historical "precursor," the mortuary or posthumous painting, most notably in the work of important American artists such as Charles Wilson Peale (1741-1847) and William Sydney Mount (1807-1868). It would seem that *all* photographic manifestations follow a teleological development straight from painting. Ruby's assertions, while entirely plausible, depart little from the legitimating, pedigree-enhancing linearity that has plagued the art-historical methodology he elsewhere decries. As Rosalind Krauss deftly noted over a decade ago, the chief shortfall of the nascent discipline of photo-history was its penchant to "map" art-historical models onto disparate bodies of images.[3] Ruby's contradiction undermines the seriousness of his efforts; his is a critique that turns back on itself, announcing its own inadequacy, and the dearth of real

alternatives for studying images of death.

Ruby is most successful in his chapter dealing specifically with memorial photography, the context surrounding its development, and the questions raised by the popularity of this mourning vehicle in the United States. We are offered first-hand accounts and archival evidence derived from the memorial photography industry: memorial and funeral cards, memorial photographs, and illustrated tombstones. Such commodities all have been seized upon as the industry of death has become a lucrative venture. (Today, Ruby tells us, videotapes and CD-ROMs, the latest in a continuum of commercial products used to exploit the very act of mourning, have begun to supersede archaic forms of memorial imagery.) For all the specious detail of this study, Ruby fails to see any connection between capitalism and death, and the relationship between exploitation and mourning.

Ruby cites a 1912 catalog that reads, "Way back in 1898, Mr. H. F. Wendell started this memorial business in a small way and in three years it developed into the largest memorial business of its kind in America and is now the largest in the world." Between the lines is another story: the birth of death-related kitsch, and funerary greed-mongering. Notwithstanding their potential cathartic efficacy, the image of death comes with a price,

USA Photography Guide is the most comprehensive and accurate sourcebook ever published on fine-art photography in the United States. The second edition of this important reference work has been expanded and completely revised.

USA Photography Guide 2

USA Photography Guide 2 lists over 2,500 entries containing essential information on galleries, museums, universities, critics, historians, journalists, book and magazine publishers, associations, residencies, awards and workshops. Individual entries include full address information, telephone and telefax numbers, E-mail addresses, opening hours, key contact people and special areas of interest. *USA Photography Guide 2* is an absolute must for photographers, gallerists, curators, editors, collectors, and anyone interested in the contemporary fine-art photography scene.

"A terrific piece of work ... and long overdue."
A. D. Coleman, New York

"Clear, comprehensive and compact."
Jean-Claude Lemagny, Paris

"An essential reference work."
Helmut Gernsheim, Lugano

USA Photography Guide 2. Edited by Bill Jay and Aimée Linhoff. 240 pages. Soft. Publication date October 1995. isbn 3-923922-36-1. $26.95

Nazraeli Press · Fine & Applied Arts Publishing
1955 West Grant Road, Suite 230, Tucson, AZ 85745, Tel (520) 798-1513, Fax (520) 798-1514

and more frequently at a premium. Ruby, however, lacks the critical distance to articulate this problem. Indeed, he assumes the role of spokesperson, offering the following reprise: "In order to accommodate the loss of a loved one, we need to celebrate his or her life. Memorializing the deceased with a photograph seems an altogether reasonable means to accomplish this task. The logic of this argument is sufficient that several industries—from memorial card manufacturers to photographic tombstone plaque makers—have arisen to facilitate these activities." Were it not for his tone and thoroughness to detail, one might question the integrity of this obvious, wholly non-critical position.

The profound irony embedded in the postmortem photograph is its human quality, its ability to render the most tragic, perhaps most integral, eventuality facing life and living. Determining meaning, as with any photograph, is elusive, a rhetorical action that plays with our most intense emotions, fears, desires and anxieties. Perhaps this accounts for the renewed interest in death imagery, and the contemporary variant embodied in the work of such noteworthy artists as Joel-Peter Witkin, Andres Serrano and Jeffrey Silverthorne—artists arguably transcending strict art-historical parameters. Any fruitful connection the author might have made to the work representing these artists, and the overlapping issues raised by their imagery, has been lost in Ruby's anthropological diatribe. His approach privileges statistical "frequency and distribution" of contemporary memorial and postmortem photography over more demanding analyses that call into action the visceral and palpable qualities with which images of death are capable of engaging us. *Secure the Shadow* strives for a ready-made answer to the manifold questions that emerge in the image of death. In doing so, it reduces the postmortem and memorial photograph to its most banal, to a sterile, soulless entity, now readied for its own scholarly entombment. ⚱

NOTES
1 William Henry Fox Talbot, "Some Account of the Art of Photogenic Drawing" (1839), in *Photography: Essays and Images,* Beaumont Newhall (ed.), (New York: The Museum of Modern Art, 1980), p. 25.
2 Roland Barthes, *Camera Lucida: Reflections on Photography*, trans. Richard Howard (New York: Hill & Wang, 1981), p. 92.
3 Rosalind Krauss, "Photography's Discursive Spaces" (1982), in *The Originality of the Avant-Garde and Other Modernist Myths* (Cambridge: The MIT Press, 1986), pp. 142-143.

← ——————————————————— →

Raised by Wolves
by Jim Goldberg
Scalo, 1995

Review by Michael Read

On *Star Trek: The Next Generation*, Captain Jean-Luc Picard's hands are forever tied by the Prime Directive. That is, as he goes about the daily grind of seeking out new life and new civilizations, the starship captain is prohibited by Federation law from acting in any way that could alter the natural course of history. Picard's purpose is merely to observe—to get in, get out and zip off to the next episode.

Documentary photographers have traditionally upheld their own version of the Prime Directive. With admiration for the myth of the hard-boiled reporter, most have endeavored to present a picture of unbreachable objectivity in their work by embracing a methodology based on "just the facts, ma'am." This approach depends on building a case to support a predetermined premise: gather enough visual "facts" and add them up, and the result, ostensibly, is the truth.

More interesting, usually, is the work of those documentary photographers who are inclined to tamper with the evidence. It's a subjective truth they're after, one that is based on questions rather than answers. And for some, the notion of "getting in and getting out" is not a simple matter.

see **60**

Take Jim Goldberg. In 1985 he began to document in words and pictures the lives of runaway teens in Los Angeles and San Francisco. Over the next ten years, Goldberg travels a long, strange road indeed. In pursuit of his subject, he does the kind of things that we've come to expect from documentary photographers: he squats in condemned buildings, cops drugs with junkies, visits emergency rooms and police stations and interviews hustlers, street preachers, social workers and distraught parents.

But what's a photographer to do when the kids he photographs call at all hours of the night, desperate for drug money or a place to crash? What's to be done when they show up at the door, tweeking out on speed with a newborn infant in tow? One thing he doesn't do is worry about preserving the objectivity of his project. It didn't take long for Goldberg to become a central figure

I called my parents a year ago and they said good luck and have a nice life. and that's all just don't come Back home

From *Raised by Wolves*.

in the lives of some of these kids, and his photographs belie a sincere caring and friendship for the individuals they portray.

Goldberg's astonishing new book, *Raised by Wolves,* does much to dismantle the tired, unspoken prime directives of the documentary tradition. The photographer seemed to understand from the outset that his project was destined to be much more than a consciousness raising

effort or a self-satisfied indictment of our social systems. *Raised by Wolves* is as much a diary of Goldberg's emotional involvement with the project as it is an account of the failure of our country to provide a safe, caring environment for its children.

The book is big in every way: between its oversized covers are more than three hundred pages, many more hundreds of photographs, and some seventy pages of transcribed dialogue between the photographer and his subjects. Its design and organization provide a compelling new recipe for visual books based on the skillful layering of disparate images, texts and found documents. Nothing extraneous was left in the mix; every last element contributes to a masterfully executed narrative that is nothing less than epic in scope.

The texts reveal Goldberg's easy rapport with the kids, and his empathy for their struggle to survive results in page after page of hair-raising testimony about a daily life composed of prostitution, drug addiction, rape and violence. Chilling, handwritten passages create an emotional resonance that sometimes makes for an almost unbearably heartbreaking experience for the reader.

Raised by Wolves is saved from being a total downer by Goldberg's blessed sense of humor and his ability to identify the ties that bind these kids together—documented among the accounts of brutality are poignant scenes of tenderness, high comedy, and good times. Preacher Hilton, a Hollywood outreach worker, puts his finger on the allure of

the streets when he reports to Goldberg that "These kids find their greatest human need, which is the need for love and affection, met out on the streets with a peer group that will love and accept them. They become greater than a family. You know, they would rather live in filth and hunger with a group that will accept them than they would with a family that will meet all their physical needs, yet inflict on them emotional pain and torment."

Goldberg's genius lies in his ability to create an authentic experience for his audience. Through his carefully constructed narrative, the reader is thrust into the sometimes brutal, sometimes exhilarating life of the streets as seen through the eyes of those that live there. We become familiar with each of these castaways in a personal way, over time, and are enabled to regard them not as victims, criminals, or statistics, but as people. It is this note of humanity that makes *Raised by Wolves* one of the most innovative, stirring and compassionate projects of the documentary tradition. ☼

<————————————————————>

Triumph of the Fact-Checker
In issue 1:2 of **see**, we neglected to mention that Jeanne Dunning, featured in the *Inscrutable Objects* portfolio and exhibition, is represented by Rena Bransten Gallery, San Francisco and Feature of New York City. In addition, J. John Priola, featured in issue 1:1, is represented in Los Angeles by Paul Kopeikin. We regret these omissions.

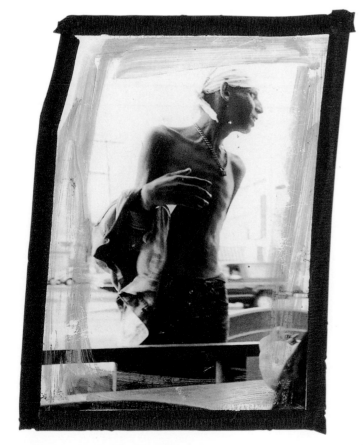

Jim Goldberg, untitled. From *Raised by Wolves*.

SOUND AND VISION

DIPPING YOUR BIG TOE IN THE PERFUME RIVER

Passage to Vietnam
CD-ROM by Rick Smolan
Against All Odds, 1995

Review by Gustavus Kundahl

If a picture is worth a thousand words, then a video is worth a thousand pictures...unless it's a CD-ROM QuickTime video, which—with its tiny size, grainy resolution and poorly dubbed Spaghetti Western audio quality—is only worth four or five pictures and a few words in change. And five pictures are worth five thousand words, which is about how much text you get in *Passage to Vietnam*, the new CD-ROM developed by Rick Smolan based on his book of the same name. Fortunately, the content and beauty of the four hundred photographs featured in *Passage to Vietnam* elevate it beyond both the limitations of the CD-ROM format and the lofty, but only partially fulfilled, ambitions of its creators.

Continuing his popular "Day in the Life of..." approach to photojournalism, Smolan sent seventy photographers to Vietnam to take thousands of pictures during a one-week span in the Spring of 1994. The surviving photos of a grueling attrition by a pool of editors (who sorted through more than 200,000 shots) are gorgeous and perplexing. Yet, after moving through the brief essays, quick comments from the photographers, and scattered mini-videos, you still emerge rather ignorant of a Vietnam in transition. It's like dipping your big toe in the Perfume River rather than taking a real swim.

Of the six "passages" to choose from, one is a journey down part of the two-thousand mile Mekong River. The immediate feel is that of *Heart of Darkness* or *Apocalypse Now*, except that instead of manning a patrol boat with a deranged Martin Sheen in the constant imbalance of unseen danger, you're tolerating the geekish surrealism of Rick Smolan superimposing a video image of himself on an exotic Mekong scene. And instead of pushing on down the river in search of the elusive Colonel Kurtz, you navigate the CD-ROM in hope of arriving at an understanding of this beautiful country and its people who, unlikely as it may have seemed before the war, have become deeply intertwined with the United States.

What you discover is that Vietnam is opening itself up, dismantling

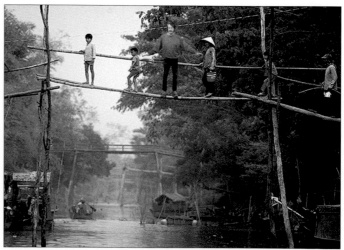

A day in the life of Rick Smolan. From *Passage to Vietnam*.

see **62**

the wall thrown up around the country after the war. This is most apparent in the surprising freedom of access given to the photographers by the Vietnamese government. By refusing to allow Vietnamese authorities to review the film and insisting on a free reign of the country, the photographers emerged with rare images of previously forbidden areas, including many of the Vietnamese military itself.

In the setting of this new era for Vietnam, *Passage to Vietnam* presents a big CEO's desk of post-it facts—fact-its, you might call them. Among the fact-its to be learned:
—Vietnam has 53 ethnic groups
—rice is important
—the twentieth century is intruding on ancient traditions
—a lot of weddings take place in Vietnam
—bicycles are important
—national cuisine includes dog, snake, turtle, pan-fried gecko, monkey and dried sea horses (the latter believed to increase sex drive).

A few side-trips off the main "passages" explore other areas of interest, but in painful brevity. Against the backdrop of indoor shots of outrageously colored temples, you get a three-paragraph fix and a few sentences of commentary on the bizarre religion of Cao Dai. Followers of Cao Dai, which originated in the 1920s, have incorporated elements of many religions, and arrived at a belief in the sainthood of Sun Yat Sen, Victor Hugo, Lenin, Joan of Arc, Louis Pasteur and Charlie Chaplin. How and why? You won't find out.

Another aside introduces the Black Hmong people. Among many beautiful photographs, you get a two-paragraph teaspoon-full explaining that the Hmong are an ancient nomadic tribe from China that settled in the northern highlands of Vietnam. They also like to dress in indigo. Anything else you want to know, you're on your own.

Other features of this CD-ROM are mere distractions, worth one look. Invitations are handed out to visit Virtual Galleries in which some of the featured photographers show

and review their past work. When you tire of exploring these micro-galleries, you might want to join an "interactive photo-editing session." Here, "interactive" means that you get to select a photograph and listen to a group of well-known editors in swivel chairs discuss its merits. One editor, commenting on the difficulty of a long-distance river shot, reminds us, "Holding up a long lens, it's hard."

The brief video clips offer a refreshing break from the otherwise motionless "passages," but are embarrassingly awkward in this golden age of electronics. CD-ROMs do not yet have the necessary space to facilitate the full-screen video imaging needed to actualize much-hyped expectations of multimedia as a new art form. By the time sufficient disk capacity is created, CD-ROMs already may be considered the 8-track tape of the '90s.

Fortunately, these unsatisfying distractions are overcome by an intelligently designed interface that propels viewers through *Passage to Vietnam*'s main selling point: the power and beauty of its photographs. A click of the Quebe (the clever 3-D navigational tool) and you're outside a rural village, on a road where farmers are spreading rice in hopes that car tires will smash the grains from the husks. Another click and you're in the chaotic bicycle and scooter demolition derby of downtown Hanoi. Click to a woman stooped over in rice paddies that are full of elaborate tombstones; a bicyclist carrying caged dogs to be butchered for dinner; an old man suddenly sobbing in a cemetery, in remembrance of the incomprehensible devastation of the war.

In the end, *Passage to Vietnam* reveals a vision of the country based on that one week during which it was visited by the participating photographers. This vision ultimately needs more history, more explanation and more time, yet it is better than not having looked at all. After you memorize the scant information presented, you will return to the images, which defy explanation. They reveal a mysterious, dynamic and impenetrable Vietnam. ♈

up in school; he hardly ever lets her go. She colors maps for Geography, practices long division.

After several hours at the table, she will be unable to stay awake any longer. She rests her head on her stack of books. She'll wake to her father's strong arms carrying her to bed, knowing that, once again, she's failed.

I never left the cottage without my camera, hidden in my jacket, but I never photographed anything outside of the house. I liked knowing I had the camera with me; hung from the leather strap around my neck, it banged against my ribs as I walked. The pressure of the camera against my body kept me safe. At night I set it on my father's bedside table where I could see the outline of the black box in the dark.

When I moved to New Orleans, the other research assistant on the circus project, a man about my age, told me to buy a gun. "This city is more dangerous than you think," he said. "You don't know what it's like here. Aren't you from some little town in Florida?"

I didn't answer. There didn't seem to be any point in telling him that Sarasota was not a little town. I let him think he knew more than me. I let him think he knew about me. Still, I wanted him to know I could protect myself. I wanted him to know that I did not need anyone.

I carried my camera everywhere in Sarasota. It was my secret. I walked downtown, studying the composition of the street, the old alongside the new: art galleries with walls made entirely of glass, curio shops, bright palm trees and stone benches set along the side of each street.

I stood in front of the Sarasota Visitors' Bureau. The Bureau had been moved to a tall, modern building, all chrome and glass and glittering in the sun. I stared up at the new building until the glare of light hurt my eyes. I would not find anything about my father there.

I try to take the story back into the past:

Fifty years ago, the circus trains roll home for the winter, my great-grandfather takes my father out to watch the trains arrive. My father sits on the trunk of his grandfather's car and watches the scene unfold before him.

The clowns are men with tired faces, carrying their own costume trunks. The skin on the camels' backs is rubbed bare and pink. The elephants stumble down the ramp as they are led from the train. The midget family looks like a group of fat children.

I couldn't take the story beyond that. What was my father thinking? I could see him, sitting on the car, holding his grandfather's hand, but I could not read the expression that flickers across his face.

Inventing my father's life revealed nothing.

The policeman with the pencil: There is no reason to keep this case open.

I studied the photographs of my father's empty rooms, held each one up to my face. What did I expect to find?

I dream of living in a museum. Not an actual museum—not the Circus Museum or the Florida Museum of Natural History. Both are too crowded, full of schoolchildren on field trips, and too neatly arranged, whole worlds under glass in perfect order—faded costumes, fossils of exotic extinct birds, everything labeled and explained.

Instead, I imagine disorder, a world where there are no rules, no routines, where no one breaks into your sleep each night. I could be alone in this dark, safe place. I would walk through the rooms and look at everything—jumbled boxes, bottles, empty picture frames—and no one, no one, would be looking at me.

She tries to talk to Nana about the photographs.

Sitting on the edge of Nana's bed, she rests her hand on the old woman's arm. For once, Nana lets the girl touch her. Emotion rises up in the girl, fills her throat. She loves her grandmother. Her grandmother will listen to her. Her grandmother will save her.

Do you ever hear noises at night? she asks.

Nana's face is turned toward the wall. Noises? What noises?

Do you hear someone—she can't say it—"my father"—in this room when you are asleep?

How could I hear anything if I'm asleep?

I mean, someone, he comes in here at night and—

Who? What are you talking about? Nana pulls the sheet over her shoulders.

He has this camera—

What camera? There's no camera in this house. You're imagining things.

But he's here, the girl says, her voice rising. She can't help it. She has to make her grandmother understand. He comes in here and takes these pictures—

I don't have any idea what you're talking about. Nana rolls over in bed and looks at the girl. What's wrong with you? Don't you know this is how it started with your mother? She had terrible dreams.

It's not my mother, the girl begins, then gives up. No one will believe her.

Could she be dreaming all the photographs? Could she dream the same dream every night?

What is wrong with you? Nana studies the girl's face. You better tell your father that you have bad dreams.

When I returned to the Sarasota police station, no one remembered me. The case had already been forgotten. I couldn't blame anyone for forgetting. There were terrible crimes to solve, triple murders, hit-and-run accidents, boats of illegal drugs. My father's absence had not affected anyone. As far as the policeman knew, he had harmed no one. He had simply left.

In my jacket pocket, I had the folded page of the Classified Section with the ad: "Photographer wanted in the 37th Precinct police station. Professional experience required." In the waiting room, the man behind the bulletproof glass window directed me down a long, brightly lit hall.

"I have to warn you," the policeman said during my interview. "This job can be gruesome."

I nodded. I needed a job. I was almost out of money. That morning I had received a letter from the production company in New Orleans. The silent movie film was done. They enclosed my final check.

"You'll be photographing evidence for the crime lab," the policeman continued. "I have to tell you, there haven't been any other applications for this job, and we need someone right away. We'll hire you. I'll take you to the lab now to do some test shots."

I followed the policeman down the hall. I knew that accepting the job meant I'd stay in Florida. Was I still expecting my father to come back?

The policeman introduced me to a man in a white lab coat who nodded briefly at me and returned to studying a slide under an enormous microscope.

The objects I was to photograph were wrapped in plastic and labeled with white cards. I was given a zoom lens. The policeman laid the evidence out on a long, low table.

Continued on page 66

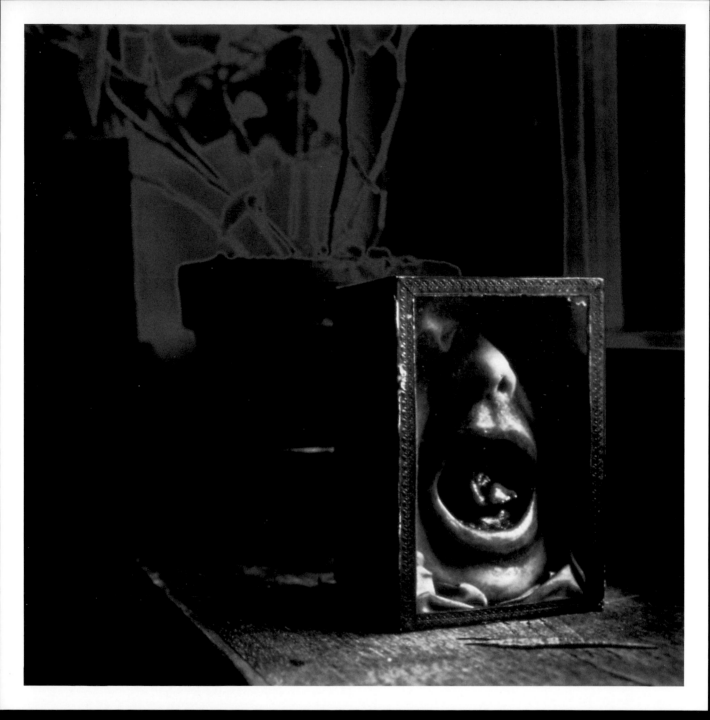

EBERHARD GRAMES *THE CRY,* 1992, SILVER PRINT, 12" x 12"

**Mr. Grames' work will be our featured
Fall photography exhibition.**

J.J. Brookings Gallery

FINE ART AND
PHOTOGRAPHS
SINCE 1970

Works also available by
Ansel Adams ● Bill Brandt ● Lynn Bianchi
Joel-Peter Witkin ● Ben Schonzeit ● Lisa Gray
Sandy Skoglund ● Irving Penn ● Todd Watts
E.S. Curtis ● Brett Weston ● James Crable
Robert Mapplethorpe and many others.

**669 Mission Street, San Francisco
California 94105**

415 546 1000

Continued from page 64

The first pictures I took—a child's shoe, a leather wallet, a woman's ripped silk blouse with a dark stain along the sleeve. I swallowed hard and tried to keep my hands steady as I photographed the blouse. I knew that I was not supposed to be thinking about where these things came from. I was not supposed to be imagining the owners of these objects. What had happened to the woman who wore the blouse? My throat tightened.

I looked through the lens and tried to tell myself that I was somewhere else. I tried to tell myself that I was already gone. The camera was there. I could disappear.

The girl imagines herself a high wire artist. She walks the wire on the tips of her shoes like a ballerina, using a parasol for balance, high above the center ring.

She cannot look down. Below her, her father holds the camera, waiting. There is no net to catch her when she falls.

Why did my father take the photographs? I could make up answers. He lost my mother and he did not want to lose me. Her image had disappeared. Did he think that he could keep me?

I want to believe this, but it's one of his lies.

The Minolta: "It's hard to tell where you leave off and the camera begins."

My mother's car lies at the bottom of the bay.

The man stands over the bed with his camera.

The policeman with the pencil: We've come up with nothing.

In New Orleans, I stand over the men with my camera.

I sat on the floor in my father's house and laid the photographs out around me turned face down like playing cards. I took the scissors and started with the first row of white squares.

Turn the picture over quickly. Study it for a minute. Cut.

In the first row, I removed all of the girl's faces. I cut out her hands. The row that followed was arms and legs, then the torso, the waist, the stomach, the tops of her thighs. I gathered up all the pieces and made a pile in my lap. Then I began. I made new pictures. I took the camera from my father's hands. With a roll of tape, I reconstructed all the scenes. This time around, the girl could grow smaller, larger. Her face could disappear. An arm extending from her hair. A bent leg where her throat would be. Her closed eyes cut out and taped to her chest. She was headless. She was nothing but an open mouth.

When I finished, I taped my pictures onto the pages of a spiral notebook. My notebook. My story. The story I wanted to be told.

My father brings home the camera on the first anniversary of my mother's death.

I know I will have to live through this day again and again. For years. I picture calendars, years of calendars, each marked with a black X on the month of January. If I cut the square that marks this day out of the calendars, it will be worse—the day signified by an empty space.

My father is pretending this day is the same as any other. In the morning, he goes off to work, leaving me to take care of my grandmother.

Nana locks me out of the room. When I try the door, the knob won't turn.

In the sun room, I wait for him to come home because I have decided to talk to him. I want to know what happened on the bridge—did she drive off the side? Was it an accident? Fear tightens in my chest. I try to breathe slowly. He comes home late, with a paper bag under his arm.

"Hi, Daddy." The word sounds unfamiliar, strange. I never call my father that. I am trying to make this day different.

"Ellen." He nods in my direction and turns to hang his coat in the closet.

"What's that?"

"This," he says, sitting down beside me on the couch, "is something I was given today. The Records department didn't need it anymore. Look." He lifts a black camera from the bag. "I brought it home to show you."

The tightness in my chest lifts and disappears. My father wants to show me something; there is something he wants me to see. When I reach for the camera, he jerks away and stands up from the couch.

"Don't touch it. I don't want it broken."

I fold my hands in my lap. My face feels hot. My father bends over the camera, fidgeting with a silver crank on the side. I tell myself, *now.*

"What did she do that night on the bridge?" I try to hold my hands steady in my lap.

My father points the camera at the floor.

"What did she do on the bridge?"

My father turns the camera toward the ceiling.

"What did she do on the bridge?" My voice shakes.

He aims the camera at a chair, at the wicker table, the window, the wall.

"Daddy," I try again.

It must be that word that does it. He looks at me. "Ellen, stop badgering me. Where's Nana? I ask you to do nothing around here but watch your grandmother and you can't even do that. I can't trust you to do anything." He shakes his head. "I don't ever want to find you playing with this camera. This is not a toy. This is mine. Do you hear me? This is mine."

I look down at my hands. "Ellen, you're not listening to me. Jesus Christ." He sounds disgusted. "It's late and you should be in bed. I don't want to see you for the rest of the evening." He leaves the room, taking the camera with him.

I sit alone in the sun room for a long time. My father does not come back. That night, he wakes me for the first time.

After the flash, I see white, white. When my vision clears, I see him slipping out the door of the room, away from me.

Why don't I scream? Why don't I call out his name?

I will not leave here. I will never leave home again. I will live in my father's house. I will stand in the doorway of the house, hidden in shadow, the camera in my hands. If my father comes back, I will catch him as he reenters his life.

He is surprised to see me; his face is frightened. I will take one picture after another of my father on the steps. I will arrange these photographs into a story.

I will block the doorway. I will not let my father back into his house.

Here I am in the doorway—I can see it. I raise my hands to take the first photograph. �

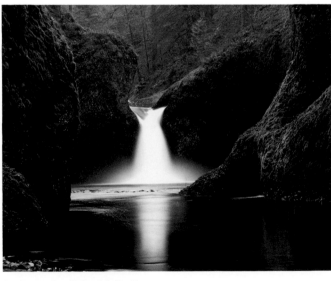

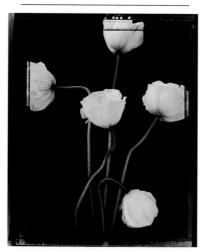
CONTRIBUTORS

DAVID BONETTI is the art critic for the *San Francisco Examiner* and previously was the art critic for the *Boston Phoenix.*

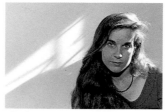

Nicole Cooley
Photo by Phil Haggerty.

NICOLE COOLEY is a writer of poems and short stories that have been published in *The Nation, Field, Poetry, Denver Quarterly* and *The Iowa Review,* among other journals. Her volume of poetry, *Resurrection,* won the 1995 Walt Whitman Prize and will be published this year by Louisiana State University Press. Cooley received an MFA from the Iowa Writers' Workshop. "The Photograph Album" originally appeared in *Voices of the Xiled* (Main Street Books, 1994).

An American expatriate in Paris during the 1920s, HARRY CROSBY lived among the writers and artists of the Lost Generation. With his wife, Caresse, Crosby operated Black Sun Press and published key works by Kay Boyle, James Joyce and D.H. Lawrence. Throughout the decade and leading up to his suicide in 1929, Crosby kept a series of diaries in which he documented the energy and eventual self-destructiveness of the Jazz Age. Always obsessed with the sun, Crosby, in his diary entry from July 5, 1928, reports the findings of his solar research. His diaries are collected in *Shadows of the Sun: The Diaries of Harry Crosby* (Black Sparrow Press, 1977).

JAMES CRUMP is a Santa Fe-based critic who has written for *The New Art Examiner* and *History of Photography.* His recent publications include *George Platt Lynes: Photographs From The Kinsey Institute* (Little, Brown, 1993) and *Harm's Way,* a book of photographs edited by Joel-Peter Witkin (Twin Palms, 1994). Crump's review of Herb Ritts' *Africa* appeared in Issue 1:2 of see.

LUKAS FELZMANN was born in Switzerland and now works and lives in San Francisco. During the past decade, his photo installations have been featured in numerous individual and group exhibitions, including a site-specific installation at the Ansel Adams Center for Photography in 1993. Felzmann has taught photography at Stanford University and at the San Francisco Art Institute. In 1992, he received the Ferguson Award from The Friends of Photography, and was honored in 1994 with a fellowship from the National Endowment for the Arts.

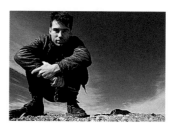

Lukas Felzmann

For nearly twenty years, NAN GOLDIN has chronicled her life and that of her extended family in Boston, Berlin, Bangkok, London and, most notably, New York's Lower East Side. Her ongoing visual diary, *The Ballad of Sexual Dependency,* has been exhibited internationally and stands as a seminal document of late-twentieth century life. Her publications include *Tokyo Love* (Scalo, 1995), a collaboration with Nobuyoshi Araki; *A Double Life* (Scalo, 1994), a collaboration with David Armstrong; *The Other Side*

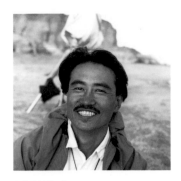

Taishi Hirokawa
Photo by Saburo Hideta.

(Scalo, 1993); and *The Ballad of Sexual Dependency* (Aperture, 1986). Goldin is represented on the West Coast by the Fraenkel Gallery, San Francisco, and in New York by Matthew Marks Gallery.

TAISHI HIROKAWA, a Japanese photographer, has exhaustively photographed his country's uneasy relationship with nuclear power during the past decade. A book of these photographs, *Still Crazy: Nuclear Power Plants as Seen in Japanese Landscapes*, was published by Korinsha Press and Co., Kyoto, Japan, in 1994. Hirokawa is represented in the United States by Photos Gallery, San Francisco.

GUSTAVUS KUNDAHL is a San Francisco-based cultural critic and aspiring novelist.

CHARLES MALONE is a graduate student in the Rhetoric Department at the University of California at Berkeley. Currently, he is writing his dissertation, "Ordering Childhood: Figures of the Child, Visions of Maturity, and the Education of Desire."

During the past decade, SALLY MANN has photographed her children at their family home in rural Virginia for an ongoing series that has been exhibited internationally and featured in books including *Sally Mann: Still Time* (Aperture Foundation, 1994) and *Immediate Family* (Aperture Foundation, 1992). Other publications include *At Twelve: Portraits of Young Women* (Aperture Foundation, 1988). Mann has received fellowships from the National Endowment for the Arts and National Endowment for the

Humanities. In 1995, she was named Photographer of the Year in the Peer Awards balloting conducted by The Friends of Photography. Mann is represented by Houk Friedman, New York.

REBECCA SOLNIT, a Bay Area cultural critic, is the author of *Savage Dreams: Journeys into the Hidden Wars of the American West* (Sierra Club Books, 1994) and *Secret Exhibition: Six California Artists of the Cold War Era* (City Lights, 1991). In 1993, she received a National Endowment for the Arts Fellowship for literature. "Daisy Chains" is excerpted from Solnit's essay, "Shifting Ground," which appears in the *Tracing Cultures* exhibition catalogue (The Friends of Photography, 1995). Solnit's article, "Out of a Picture by Arbus," appeared in the premier issue of see, and her review of Gilles Peress' *Farewell to Bosnia* appeared in Issue 1:1.

MIKE and DOUG STARN's groundbreaking use of photography and sculpture, in the words of critic Dana Friis-Hansen, "has always possessed a material existence that most photography lacks. Theirs is a constructive, process-oriented art in which the final product reveals all traces of its creative generation but also its fragility, decay, and, by extension, history itself." In Autumn, 1996, an exhibition of the Starns' recent work will be organized by The Friends of Photography . Their work is represented by Leo Castelli and Pace/MacGill.

TRACING CULTURES is one of three exhibitions that constitute *Points of Entry,* a collaborative project of The Friends of Photography, the Museum of Photographic Arts (San Diego) and the Center for Creative Photography (Tucson). After appearing at the organizing institutions, the shows will tour nationally beginning in 1996. Artists in TRACING CULTURES include: ALBERT CHONG was born of Chinese and African descent in Kingston, Jamaica. His work has been shown in numerous group and solo exhibitions in Jamaica and

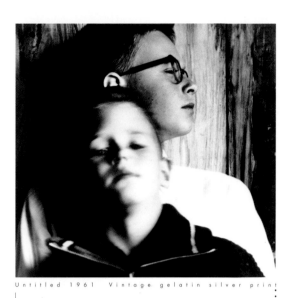

Ralph Eugene Meatyard

September 7 - October 28 1995

Untitled 1961 Vintage gelatin silver print

SHAPIRO GALLERY
20TH Century Photography
Gallery hours: Tues - Sat 11am - 5:30pm
250 Sutter St. SF, CA 94108 415.398.6655

"JUST ANOTHER DAY IN PARADISE"

January '95	Jack Pierson
March	John Currin
April	Nayland Blake
May	Karen Kilimnik
September	D-L Alvarez
October	Sue Williams
January '94	Charles LeDray
February	Dan Graham Jeff Wall Rodney Graham Lincoln Tobier
March	Rirkrit Tiravanija
May	Fred Tomaselli Christian Schumann Michael Gonzalez
June	Gustav Troger
July	D-L Alvarez Ramon Churruca
September	Steven Pippin
October	Maureen Gallace
November	Catherine Opie
December	Erwin Wurm
January '93	Rodney Graham James Welling
February	Keith Coventry
March	Karen Kilimnik Glenn Ligon Daniel Oates Suzanne McClelland
April	Andrea Zittel
May	Siobhan Liddell Charles LeDray
June	Nayland Blake Alex Pearlstein
September	Daniel Oates
October	Andrei Roiter
November	Raymond Pettibon
December	Part Fantasy: drawings by lesbian artists
January '92	David Kremers
February	Jack Pierson Kay Rosen Nicholas Rule
March	Christopher Wool Georg Herold Albert Oehlen
April	Thom Merrick
May	Andrei Roiter
June	Zoe Leonard Felix Gonzalez-Torres Robert Gober Kiki Smith
September	The Painting Show
October	Michael Jenkins
November	Richard Prince Paul McCarthy Daniel Oates
December	Jack Pierson

Jack Hanley Gallery 41 Grant Avenue San Francisco CA 94108 415-291-8911

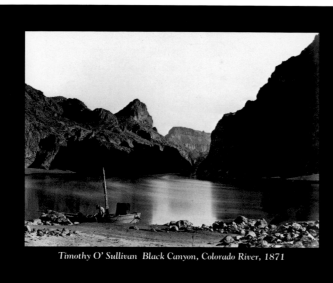
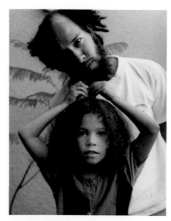

Albert Chong and his daughter, Chinwe
Photo by Michael Read.

throughout the United States. In 1994, he designed an installation for the "Open Space" series at the Ansel Adams Center for Photography. He is represented by Porter Randall Gallery, La Jolla, California and Catherine Edelman Gallery, Chicago. YOUNG KIM was born in Korea and has been exhibiting her work since 1987. In 1994, she received a National Endowment for the Arts/Arts International Travel Grant for Artists. She currently lives in San Francisco and teaches at the San Francisco Art Institute and the Academy of Art College. KOMAR & MELAMID, a collaborative team, is comprised of Vitaly Komar and Alexander Melamid, both born in Moscow and currently living in New York City. They are credited with founding the SOTS movement, a Soviet version of Western Pop Art. In 1981, they received a grant from the National Endowment for the Arts, the first Russian artists to do so. DINH Q. LE was born in Vietnam and since 1989 has shown his work in group and solo shows throughout the United States. He also has created a number of public art projects. He received an M.F.A. from the School of Visual Arts in New York and recently received a Visual Artist Fellowship from the National Endowment for the Arts. Works from his series *Celebrity Portraits* were featured in issue 1:1 of see. GAVIN LEE was born in Sacramento, California. His work has been featured in exhibitions throughout California. His photo-

installation *Concerning George* was inspired by the story of his great-grandfather, George Lim Fong, a Chinese American living in San Francisco who attempted to assassinate a visiting Chinese government official in 1910. Lee is represented by Gracie Mansion, New York. MARÍA MARTÍNEZ-CAÑAS was born in Havana, Cuba and has been featured internationally in solo and group exhibitions during the past three decades. Her series *Quince Sellos Cubanos/Fifteen Cuban Stamps* was inspired by Cuban stamps featuring the works of Cuban painter Amelia Peláez. Martínez-Cañas currently lives in Miami, Florida, and is represented by Catherine Edelman Gallery, Chicago. RUBÉN ORTÍZ TORRES was born in Mexico City. As both a painter and a photographer, he has been featured internationally in solo and group exhibitions since 1982. Ortíz Torres currently lives in Mexico and is represented by Jan Kesner Gallery, Los Angeles. TRACING CULTURES is sponsored by AT&T's New Art/New Visions program; *Points of Entry* is supported by grants from the Lila Wallace-Reader's Digest Foundation and Metropolitan Life Foundation.

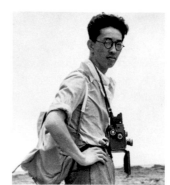

Yosuke Yamahata, 1943

YOSUKE YAMAHATA's images of Nagasaki are featured in *Nagasaki Journey,* recently exhibited at the Ansel Adams Center for Photography, the International Center of Photography (New York) and Chitose Pia Hall (Nagasaki). Yamahata's photographs constitute the most extenisve document known to exist of the destruction of Nagasaki. ♀

STATE OF THE ART

AN ART DIVIDED

BY ANDY GRUNDBERG

For two months I've been looking closely at the exhibition *After Art: Rethinking 150 Years of Photography,* a selection of more than 150 images drawn from the collection of Joseph and Elaine Monsen, trying to decide if we are getting any closer to bridging contemporary art's great divide: the territory between the art of photography and contemporary art that consists of photographs.

My conundrum isn't any fault of the exhibition, which was organized by Chris Bruce of the Henry Art Gallery and started its national tour at the Ansel Adams Center for Photography in May and June. (If it were, I would feel partly responsible, since I wrote an essay for the catalogue and spoke frequently with the curator in the show's formative stages.) Rather, the exhibition really brings the issue into focus, suggesting that what divides "fine-art photography" from "contemporary art using photographs" is nothing more or less than our conventional ways of thinking about photographic aesthetics.

The argument goes something like this: for most of photography's first 150 years, we have based its status as an art on its distinctiveness as a medium. In other words, to put a complex idea simply, what photography could do that painting and drawing couldn't was what made it an art. This emphasis on photography's status *as a medium* led naturally to it being considered a special case: its history was written as if it were an autonomous means of making images, just as the history of art was written as if photography did not exist.

This all changed beginning in the 1960s and 1970s, when contemporary artists began to consider the impact of photography as a form of cultural representation. Just as Andy Warhol's silk-screened renditions of Brillo boxes spoke to the dominion of advertising images in contemporary life, his silk-screened versions of photographs of car accidents and electric chairs made explicit the force of photography on mass culture in the United States. So instead of seeming interesting as a medium of art, photography was seen as an instrument of representation.

This explains why artists like Cindy Sherman came to photography from a far different perspective than, say, Minor White. Sherman's work of the 1980s was not based on a quest to demonstrate photography's potentials as a medium of art, but on a recognition that photographic images were complex and underestimated agents of how we understand ourselves and the world around us. And for older Conceptual artists like John Baldessari, Bruce Nauman and Bernd and Hilla Becher, photographs were interesting precisely because of their non-art, putatively mechanistic qualities.

How, then, do we put photographs by artists of the last thirty years together with photographs that are understood in terms of conventional histories of photography? *After Art* assays one promising approach, forsaking chronology to focus on similarities of theme, subject matter and intention. At its best, this approach allows viewers to make wonderfully unexpected connections across time, making the contemporary art more understandable and less forbidding. The downside is that we can easily mistake similarities of form for similarities of meaning. Take, for example, Alfred Stieglitz's "Equivalent" from the mid-1920s and James Welling's "Crescendo" from 1980. The Stieglitz image, recognizably of clouds but otherwise removed from the everyday world, is Modernism's most eloquent expression of the potentials of photographic abstraction.

Stieglitz wanted the image to be appreciated like music, without reference to any particular subject matter, in effect wearing its emotional charge on its sleeve.

Welling's picture, a small contact print almost exactly the size of the Stieglitz, looks quite similar although its contorted pattern of highlight and shadow is not readily identifiable. But instead of being an image about abstraction's possibilities as an escape from the material world, "Crescendo" is a commentary on abstraction's limitations. Read me as music if you wish, the picture seems to say, but I'm really all show and no go. Its blank refusal to represent anything in particular (other than the crumpled foil that created it) suggests that, in terms of late twentieth-century art, abstraction is a dead end, not an opening.

So, obvious similarities between old and new photographs don't tell all the story; their differences have to be taken into account, too. The larger lesson of *After Art* is that the task of rethinking 150 years of photography in light of the present is a huge project that requires not only new exhibitions but also new criticism, new teaching and new texts. Histories of photography that treat photography as a medium— and all of the ones I've read do—need to be supplanted by histories of photography as a specialized and influential form of representation. Existing histories of art will need to be rewritten, too.

When this happens, the seemingly artificial divide between artists using photography and photographers will disappear, as will the vestigial gap that separates photography from art as a whole. ☿

**Alfred Stieglitz, *Equivalent,* ca. 1925.
From *After Art.***

**James Welling, *Crescendo,* 1980.
From *After Art.***

see **72**

Rock Box Mystery

By Samone Bos

Series Editor Deborah Lock
Editor Pomona Zaheer, Arpita Nath
Project Editor Camilla Gersh
Assitant Editor Katy Lennon
Designer Emma Hobson
Art Editor Jyotsna Julka
Managing Editor Soma B. Chowdhury
Managing Art Editor Ahlawat Gunjan
Art Director Martin Wilson
Senior Producer, Pre-production Ben Marcus
Illustrator Emma Hobson
DTP Designers Anita Yadav,
Nityanand Kumar
Picture Researcher Surya Sankash Sarangi

Reading Consultant
Shirley Bickler
Subject Consultant
Dr. Ronald L. Bonewitz

First published in Great Britain in 2015 by
Dorling Kindersley Limited
80 Strand, London, WC2R 0RL

Copyright © 2015 Dorling Kindersley Limited
A Penguin Random House Company.
15 16 17 18 19 10 9 8 7 6 5 4 3 2 1
001—271725—June/15
All rights reserved.

A CIP catalogue record for this book is available from the British Library.
ISBN: 9780241182802
Printed and bound in China

The publisher would like to thank the following for their kind permission to reproduce their photographs:
(Key: a-above; b-below/bottom; c-centre; f-far; l-left; r-right; t-top)
1 Corbis: Louie Psihoyos. **4 Dorling Kindersley:** Oxford University Museum of Natural History (bl/Background also appears on
16, 18, 20, 22, 34, 36, 38, 50, 52, 54, 66, 68, 80, 82, 94, 96, 98, 112, 114, 116, 118, 120). **5 Dorling Kindersley:** Natural History
Museum, London (br/Background also appears on 17, 19, 21, 23, 35, 37, 39, 51, 53, 55, 67, 69, 81, 83, 95, 97, 99, 113, 115, 117,
119, 121). **6 Dorling Kindersley:** Oxford Museum of Natural History (ca). **Pearson Asset Library:** Coleman Yuen (cla/Brush).
11 Getty Images: Chicago Tribune / Contributor. **14 Dorling Kindersley:** Thomas Marent (cr); Rough Guides (cl, cb).
15 Getty Images: Nic Taylor / E+ (br). **18 Dorling Kindersley:** Natural History Museum, London (c). **19 Dorling Kindersley:**
Natural History Museum, London (cr, br). **22 Dorling Kindersley:** Natural History Museum, London (cb, cb/Granite). **Fotolia:**
Georgios Kollidas (br); John Takai (tc). **23 Dorling Kindersley:** Museum of London (clb); Natural History Museum, London
(cla). **Fotolia:** Georgios Kollidas (cra, br). **24 Dorling Kindersley:** Oxford University Museum of Natural History (tc).
Dreamstime.com: Humbak (ca). **26-27 Dreamstime.com:** Ensuper (Paper texture). **32 Dorling Kindersley:** Oxford University
Museum of Natural History (cra). **33 Dreamstime.com:** Humbak (bl). **36 Dorling Kindersley:** Natural History Museum, London
(clb, br). **37 Dorling Kindersley:** Natural History Museum, London (crb, bl). **39 Dorling Kindersley:** Natural History Museum,
London (bl). **40 Dorling Kindersley:** Natural History Museum, London (ca). **Dreamstime.com:** Humbak (ca/Plasticine).
42 Dorling Kindersley: Oxford Museum of Natural History. **43 Alamy Images:** Jupiterimages. **50 Dorling Kindersley:** NASA.
52 Dorling Kindersley: Natural History Museum, London (cr). **55 Dorling Kindersley:** The Natural History Museum, London
(cb); Natural History Museum, London (clb). **56 Dreamstime.com:** Humbak (ca). **63 Dreamstime.com:** Humbak (br).
65 Getty Images: Ferguson & Katzman Photography / Halo Images / UpperCut Images (cr). **66 Alamy Images:** Realimage
(br). **Dorling Kindersley:** Whipple Museum of History of Science, Cambridge (cl). **67 Alamy Images:** Michele and Tom
Grimm (crb). **68 Dorling Kindersley:** Rough Guides (br). **69 Dorling Kindersley:** National Trust (tr); Rough Guides (br).
70 Dorling Kindersley: Natural History Museum, London (cla). **Dreamstime.com:** Humbak (ca). **73 Dorling Kindersley:** Natural
History Museum, London. **75 Dorling Kindersley:** Natural History Museum, London. **79 Getty Images:** Frans Lanting / Mint
Images (clb). **81 Dorling Kindersley:** Rough Guides (b). **82-83 Getty Images:** Herbert S. Wilburn Jr. / National Geographic.
84 Dorling Kindersley: Science Museum, London (cla/Scheelite). **86 Dorling Kindersley:** Rough Guides. **Getty Images:** Frans
Lanting / Mint Images (cl). **87 Getty Images:** Oliver Strewe / Lonely Planet Images (bc). **88 Dorling Kindersley:** Science
Museum, London (bl). **92-93 Dreamstime.com:** Humbak (b). **100 Dreamstime.com:** Humbak. **105 Dorling Kindersley:**
Natural History Museum, London (bc). **Dreamstime.com:** Humbak (c). **107 Dorling Kindersley:** Natural History Museum,
London. **112-113 Alamy Images:** Hilary Morgan (c). **112 Corbis:** Francis G. Mayer (br). **113 Alamy Images:** Marc Tielemans
(cr). **Corbis:** Reuters (cr/Diamond); Fred Ward (crb). **121 Alamy Images:** Imagebroker. **Jacket images: Back:** Dorling
Kindersley: Natural History Museum, London ftl, cra. **Spine: Dorling Kindersley:** Natural History Museum, London.
All other images © Dorling Kindersley
For further information see: www.dkimages.com

A WORLD OF IDEAS:
SEE ALL THERE IS TO KNOW
www.dk.com

CONTENTS

MUSEUM OF NATURAL HISTORY PLAN

BACK ENTRANCE

MAIN ENTRANCE

4

FIRST FLOOR

GROUND FLOOR

KEY

Ladies' room	Reptiles	Microscopic!
Men's room	Mammals	Fossils
Information	Sea Life	Diamonds
Cafeteria	Ocean Giants	Minerals
Telephone	Garden Life	NASA
Gallery	Plants	Space Rocks
Magnify!	Arachnids	Telescopic!
Dinosaurs	Insects	Planets

CHAPTER 1

THE HOLIDAY OF A LIFETIME?

"Gobi Desert Dinosaur Digs regretfully advises that your excavation adventure has been cancelled due to severe sandstorms."

Flint Welles read his mother Pam's e-mail and groaned like a *Tyrannosaurus* with a toothache. They were supposed to fly to Mongolia that evening!

"Sorry, Flint," said Pam, "but with these sandstorms, we can't possibly dig up dinosaurs."

Flint was disappointed, but he was also a problem solver.

"Fine," he sighed glumly. "Let's go to some theme parks. Rollercoasters might ease my pain."

"I'd rather save my holiday time for the next dig," Pam shrugged. "Why not join me at the office?"

Pam's 'office' was the museum where she worked as a geologist. It was normal for kids to visit the museum for an outing, but now Flint was expected to spend a whole week there.

"Mum, I'll turn into an exhibit!" Flint yelped, his eyes bulging. "I'll be mummified with boredom!"

Pam brightened. Flint knew she had a joke up her sleeve.

"Some people think geology really rocks, Flint," she grinned. "Get it? Rocks? Geology *rocks*?"

Flint understood, but he did not think it was funny.

The next morning, Flint sat yawning at Pam's desk. There was nothing to do. He decided to break the world record for the longest chain of paper clips. The geology department was full of jokers like his mum.

"Got a new assistant, have we?" chuckled the first seven geologists he met. By the eighth geologist, Flint's response was stony.

"Thanks for your comment, but I'm 12 years old," he said. "I'm Pam's son, Flint."

"Enchanted to meet you, Flint," grinned the eighth geologist. She held a tattered cardboard box. "I'm Sue, and I've got a job for you!"

"A job?" Flint thought. Not only was
he forced to hang out in the museum,
but he was being put to work! During the
school holidays!

"I'm *not* the new assistant," he replied
to Sue flatly.

Sue laughed as she handed Flint the box.

"Take a look inside," she said. "See what
you think!"

With that, Sue left the room.

Flint looked at his mum typing on
her computer. He raised his eyebrows.

"Open it, Flint," Pam said mildly.
"You might get a nice surprise."

Flint felt a twinge of curiosity. What if the box contained treasure – or bones from a very small dinosaur? He lifted the cardboard flaps, excited with anticipation.

POOF!

Out burst an enormous cloud of gritty orange dust.

"It's a genie!" Pam hooted. "And it needs a bath!"

"I thought those sandstorms were in Mongolia," Flint spluttered. He reached into the box, like a magician preparing to pull a rabbit from a hat.

"Rocks!" Flint groaned.

Grumpily, he removed 24 rocks and one folded letter from the box. He opened the letter. Two sticks of bubble gum slid out.

Hello, rock experts!

I'm Ivy Singh, great-granddaughter of the famous Ivy Singh. I manage the family gum business. Please enjoy a sample of our newest flavour "I Say, I Say, Açai."

I found this box hidden in the floor of our family jungle tree house. It must have been there for decades! If you can identify the contents, please consider it a donation.

Great-Grandmama collected many souvenirs in her long lifetime. We ought to build our own museum!

Best wishes,

Ivy Singh (the third)
Chief Executive Officer
Bubbles? No Troubles! Inc.
A subsidiary of PILOT GUM

Flint's spine tingled. His best friend
Archie's family had a holiday home by
the sea, but a tree house in the jungle was
something else! He noticed that the box
was covered in stamps from Brazil. Could it
be from the Amazon?

"Mum, have you ever heard of someone
called Ivy Singh?" he asked.

"Absolutely!" Pam replied. "Ivy was
a superstar adventurer way back in
the 1920s and '30s. She was a pilot,
palaeontologist and dancer!"

"Way back in the 1920s and '30s," Flint
repeated. A sly grin spread across his face.
"When you were my age?"

"Flint Welles!" Pam yelped. "When I was
your age, Ivy Singh was a very old woman.
She lived to be 105, I think. There is
a Hollywood movie about her life."

Flint read the letter to his mum, as
she inspected the rocks.

"Well," Pam said. "There certainly is
an air of mystery about this collection of
stones. I wonder why Ivy kept them hidden."

Flint unwrapped one stick of bubble gum, and gave the other stick to Pam. He hoped it would help them think.

THE AMAZING

IVY Life Story

SINGH!

Pilot • Palaeontologist • Dancer

"Good gum!" Flint gurgled, as he popped an enormous green bubble. He looked at his mum and laughed. Pam's bubble was the size of her head!

Flint examined the tattered old box. He began peeling off the exotic Amazon stamps for Archie, who was an avid stamp collector.

After removing the jaguar and the three-toed sloth, Flint found that the macaw was a little stuck. As he lifted the box, there was a CLUNK!

The box looked empty… but was it?
He tilted it to the left.
CLINK!
He tilted it to the right.
CLANK!
He tipped it upside down.
CLONK!
Flint's hunch was right. The box had a false bottom!

An old notebook spilled onto the table. There was a message printed on the cover: 'TOP SECRET.' Inside, on the first page, it said, "Diary, notes and musings by Miss Ivy Singh. If you're not me, buzz off and stick your nose somewhere else!"

Flint chuckled as he opened the book's dusty old pages.

"Sorry, Ivy!" he laughed. "My nose and I aren't going anywhere!"

Geological Timeline

The Earth is approximately 4.5 billion years old. Geologists have been able to date our planet by looking at the type and depth of the rock layers.

Mya = millions of years ago

Precambrian (4,600–550 mya) Simple plants and animals evolve. Ancient zircon crystals that date back to this era have been discovered in Australia.

Devonian (480–362 mya) Also known as the Age of the Fishes, many fossils can be found in the sandstone, limestone and slate that formed during this period.

Jurassic
(195–141 mya)
Large dinosaurs roamed the land. Rock sediment found in the deep sea was formed during this period.

Permian
(290–248 mya)
Large areas of desert cover the land. One of the world's oldest mountain ranges, the Ural Mountains in Russia, was formed during this period.

Carboniferous
(362–290 mya)
During this period plants thrived and when they died, they fell into the water and were compressed. This created much of the coal that we use today.

Quaternary (2 mya)
Humans appear on the plains of Africa and use rocks as tools to help them hunt and build.

17

Rock or Mineral?

Mineral

A mineral is a solid that forms naturally – not made by humans. Most minerals are made from two or more chemical elements, such as carbon, oxygen and calcium to make calcite. Some minerals take thousands of years to form, others take just minutes.

Quartz
Quartz is a common mineral but comes in many different colours – some of these are valued as semiprecious gems.

Feldspar
Feldspars are common minerals and make up 60% of the Earth's crust.

Rock

Rocks are made up of minerals. Different amounts of minerals make different rocks. The different minerals can be clearly seen in some rocks, but a microscope is needed to see them in other rocks.

Granite
This piece of granite is made up of three different minerals. If you look closely you will be able to see the individual crystals within it.

Mica
Some types of Mica split into thin, clear sheets were once used as window panes.

The Rock Cycle

Rocks are constantly being formed and changed in a process called the rock cycle. Rocks that have been broken down are carried out to the sea, where they are pushed down to form new sedimentary rocks. These in turn are heated and then cooled to form igneous rocks that are eroded by the weather and returned to the sea.

Transportation
Sediment is transported by water, wind and ice.

Sedimentation
Rocks are carried into the water and fall in layers.

Sedimentary rock
This is formed when the layers of rock are squashed together.

Metamorphic rock
This is formed when sedimentary rocks are heated without melting.

20

Earth started its life as a huge ball of molten rock. Around 4 billion years ago, the outer layer cooled and formed a hard crust. This made life on Earth possible.

Weathering and erosion
Water flow breaks rocks down to form sediment.

Igneous rock
This is formed by the cooling of magma.

Magma
Liquid rock rises from inside the Earth.

21

ROCK

Hall of Fame

Every rock fits into one of three categories: igneous, sedimentary or metamorphic. Igneous rocks can further be divided into intrusive and extrusive rocks. Take a look in the Rock Hall of Fame to discover the differences between each group.

IGNEOUS ROCK

Presented to
GRANITE GANGSTERS
Platinum album:
ROCK BOTTOM

Top hits: 'Pegmatite',
'Obsidian', 'Pumice'

How the band formed: by the cooling of magma. Some formed inside the Earth and some outside.
Rock style: large crystals from slow cooling inside the Earth, or small crystals or glassy appearance if cooled on the surface.

METAMORPHIC ROCK

Presented to
THE CLEAN SLATES
Platinum album:
OUT ON THE TILES

Top hits: 'Marble', 'Quartzite',
'Mi'matite', 'Schist'

How the band formed: when rocks were buried under the Earth's crust, high pressures and temperatures caused them to change, forming metamorphic rock.
Rock style: often with small grains in straight lines.

SEDIMENTARY ROCK

Presented to
THE FLINTSTONES
Platinum album:
SEDIMENTARY, MY DEAR WATSON!

Top hits: 'Limestone', 'Chalk',
'Peat', 'Flint', 'Sandstone'

How the band formed: when small rocks that had broken away from larger rocks were squashed down and fused together.
Rock style: many-layered and containing lots of different types of rock, fossil and plant debris.

CHAPTER 2

THE LADIES

Flint was reading Ivy's notebook when Sue returned to the office holding a large stereo.

"Far too quiet in here!" Sue bellowed, plugging in the stereo and twisting the dials.

"Let me guess – geologists like rock music?" Flint replied, with a triumphant grin.

Sue shook her head. "Heavy metal is more my thing!" She tuned the stereo to a heavy metal station. Together, Pam and Sue started head banging!

Flint clamped his hands over his ears and looked on, dumbfounded. Old people could be so embarrassing!

"After all, five percent of Earth's crust is iron!" shrieked Sue, over the squealing guitars and throbbing drums. "That is serious heavy metal!"

Soon Flint couldn't stand the noise any longer. He marched over to the stereo and turned it off. Pam skulked back to her desk and pretended to mope. Flint passed Ivy's letter to Sue.

"Intriguing!" Sue exclaimed when she had finished reading. "I once saw a Hollywood movie about Ivy Singh's life."

"Flint," she said quietly, "did you read the labels?"

"Labels?" Flint yelped.

"Labels!" Sue repeated, pointing at the green-blue rock.

Flint peered at the tiny label with its neat writing.

"The Ladies?" he said.

Sue nodded and held up the other rock. It was pink and shimmery.

The Ladies

Flint tried to decipher the age-worn writing. Ivy's big adventures did happen 90 years ago.

Disappearing Act

"Disappearing Act?" he mumbled as he read the next label, before breaking into an enormous grin. "Mum! Sue! My work is done! The rocks are identified!"

"Okay, Flint," Pam replied calmly. "Cryptic clues can be tricky, though."

"Very tricky," added Sue, wiggling her eyebrows. With that, she dashed out the door.

Cryptic clues? Flint's mind boggled.

He turned over each rock and took in Ivy's spidery scrawl. Flint knew that rocks had names like granite, marble and gneiss. These rocks were labelled in riddles – or were the labels codes?

"Of course Ivy Singh didn't give these rocks their *proper* names," he groaned.

Flint sorted the rocks according to their labels. There were five groups: 'The Ladies', 'Oddballs and Weirdoes', 'Disappearing Act', 'Now You See It', and, most mysteriously, 'Out of this World'.

It did not take a geologist to figure out the identity of one of the 'rocks'. It was an exquisite black pearl resting in its shell.

"Mum, can rocks be male or female?" Flint asked sheepishly.

When Pam stared at him blankly, he tried to explain. "The label on this pearl says 'The Ladies'. I thought it might be a female rock!"

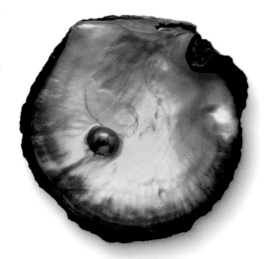

Pam laughed. "No, Flint, but I knew a girl named Pearl when I was growing up."

Flint nodded. He wanted to figure this out! He observed each rock, and scribbled down some notes.

Shell: black; holds some type of black pearl. Whatever happened to pearly whites?

Blue-green rock: bright green and shiny; colour of the sea.

Red rock: tiny rock – almost a speck! Some type of gem? Brilliant red.

Pink rock: large; looks like a healing crystal from a 1960s hippy shop – somewhere that does palm readings! Odd, milky pink.

Grey rock: globby! Grey! Ugly!

Flint flicked through Ivy's notebook and discovered something interesting.

Tuesday, 9 August, 1927

Ia Orana! (That's Tahitian for 'hello'!)

Cousin Cecil is such a character. When he heard I was off to Tahiti, he lent me his Mark V diving helmet. As soon as I reached the island, I dipped straight in the Bora Bora lagoon with my diving instructor Poema.

Mark V diving helmet

Ra

Ra and I have flown over exquisite waters, but Bora Bora really was the cherry on the cake! I almost forgot my terror of being chomped by a shark or zapped by a stingray.

Manta ray

I did see a manta ray, and it was majestic!

In this underwater wonderland, I gathered black oyster shells in my net. It was like playing lacrosse!

Later on the beach, Poema and I prised open the shells. Yes, we had a hearty feast of oysters! In one shell, like a little glob of midnight, sat a magnificent black Tahitian pearl.

I named my pearl after Poema (which means 'deep-sea pearl'). Poema (the pearl) will be a perfect match for The Ladies, won't she?

My pearl Poema

The shell was definitely Poema, Ivy's Tahitian pearl. Flint eyed the other rocks. The tiny red rock glittered like a jewel.

"Pearl and Ruby!" he shouted, thinking of the pearl and red rock. "The Ladies have women's names!"

Pam whooped and passed Flint a rock encyclopedia.

"Use this to find the others!"

Flint had a friend named Jade. Wasn't jade a type of rock? He flipped through the encyclopedia. Jade was a green mineral, but it wasn't what he was looking for.

"Think about your grandmothers," Pam urged.

Flint frowned. Grandmothers?

"Is this rock… beryl?" he muttered, opening to pages with emeralds and aquamarine. The blue-green rock was a perfect match.

"Eureka!" Pam cheered. "Nanna Beryl would be proud."

Flint's other grandmother was Rose.

His fingers raced to 'R' in the index.

"Look!" he yelped, pointing at a pink crystal. "That makes pearl, beryl, ruby and rose quartz."

"You're getting the hang of it," Pam replied, excited.

"But what about this globby thing?" Flint asked, pointing at the ugly grey rock.

"Honestly, Flint," his mother answered. "I've never seen anything like it!"

Do you know anyone who has the same name as a rock or mineral?

PEARLS

Pearls are precious gems, which are often sold at a high price, but what is their purpose and how are they produced?

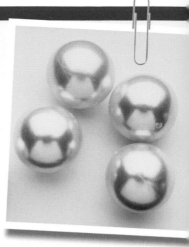

Formation

Pearls are most commonly found growing inside the shells of oysters. They are formed when a small particle, which might be harmful to the oyster, gets into the shell and becomes stuck in the mantle.

Process

1. A particle of grit finds its way into the oyster's shell.

2. The mantle (protective layer that covers the oyster's organs) releases minerals that form nacre, or mother-of-pearl. The nacre covers the invading particle.

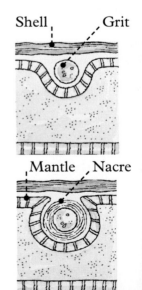

3. The layers of nacre build up in a sphere shape around the grit to form a pearl. The pearl breaks free keeping the oyster safe from harm.

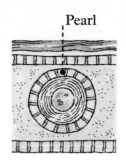
Pearl

Farming

To meet demand, oyster farms are needed to produce pearls quickly. It can take up to four years for a farmed pearl to fully develop. Farmers plant a tiny sphere of mother-of-pearl into the oyster and then place it back into the sea. The oyster will then form a pearl around the sphere.

Finery

Many people place a great value on pearls. They are used to decorate jewellery and ornaments and are valued by their colour, shape and texture.

GEMSTONES AND BIRTHSTONES

From sparkling diamonds to rich-red rubies, some rocks are valuable and are known as gems. They are mined from the Earth at huge expense, cut and polished and worked into jewellery. Some people believe it is lucky to wear gems that are linked to their months of birth. Which is your birthstone?

JANUARY – **Garnet**

FEBRUARY – **Amethyst**

MARCH – **Aquamarine**

APRIL – **Diamond**

MAY – Emerald

JUNE – Pearl

JULY – Ruby

AUGUST – Peridot

SEPTEMBER – Sapphire

OCTOBER – Opal

NOVEMBER – Topaz

DECEMBER – Turquoise

37

GEM CUTS

Gemstones have a rough and dull surface when they are first extracted from the Earth. In order to get them into a sparkling and elegant shape, they need to be cut and polished. There are four types of precious stones: diamonds, rubies, sapphires and emeralds. All the others are called semiprecious.

People who cut and polish gems are called lapidaries.

POPULAR GEM CUTS

Table cut Pear brilliant Round brilliant

Cabochon Rose cut Emerald or step cut

FACETING

The best way to boost the beauty of a transparent (see-through) gem is to cut the surface into a number of facets or faces. This is done by grinding the gem down with a rotating wheel.

A piece of rough diamond with eight sides is selected.

The point at the top is sawn off to form a large top facet.

The stone is rounded and the top is cut.

Pairs of facets are cut on the top.

The smaller facets are cut.

The diamond is rotated and the bottom facets cut.

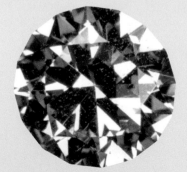

The finished brilliant cut highlights the colours of the stone, making it twinkle.

CHAPTER 3

OUT OF THIS WORLD

"WUUUUUURRRP!" grumbled Flint's stomach. It was growing impatient. Flint had been staring at rocks for hours.

"Buy that beast a sandwich!" Pam chuckled, handing her son a five-pound note. "After lunch, explore the museum. I don't want your holiday to be all hard work."

"Out of this world," Flint mumbled. It was the next code he was trying to crack.

"No, not that far!" quipped his mum. "The cafeteria is on the second floor. Follow the signs."

CAFETERIA →

Flint smiled at Pam's joke. He pointed at four rocks on the desk, all labelled 'Out of this World'. Three rocks seemed to belong together. They were light brown, black and silvery grey. Once again, a peculiar glob-shaped rock stood out from the rest.

"Do any of these rocks look familiar, Mum?" he said.

Pam smiled secretly.

"Well, you wouldn't trip over them in the street," she replied. "Look around, Flint. Get your thoughts in orbit!"

"Thoughts in orbit?" Flint wondered.

Just like Ivy Singh, his mother did have a weird way with words!

The museum's cafeteria reminded Flint of the zoo. Instead of apes and hyenas, this zoo brimmed with toddlers. Worse still, every toddler was covered in yoghurt or avocado. He shuddered at some green-faced triplets.

"Grungy! Gross! Gruesome!" Flint muttered to himself.

After gobbling his sandwich, he fled the room full of goo.

Flint wandered the marble floors and stopped by his old favourites, the dinosaurs.

He stared, amazed, at the *Velociraptor* fossil, and imagined finding one in Mongolia.

Before he became too glum about his cancelled dig, Flint sauntered into the space exhibit. This was the first time he had seen the museum's new NASA space shuttle display. Flint's thoughts went into orbit as he examined the powerful engines.

Space!

If one idea was 'out of this world', it was visiting space!

With his brain firing like a rocket, Flint raced back to the office and rummaged through Ivy's diary.

Pam peered curiously over her noodle soup.

"Ivy Singh never went to space," Flint announced. "Space went to Ivy Singh!"

Flint's eyes landed on a word in the diary that explained everything: 'meteorite'.

Monday, 5 September, 1928

G'day!

I've just returned from Australia, where I crossed the Nullarbor Plain on a camel. I think a kangaroo ride would have been less bumpy! For a few days there, Percy (my camel) was a cantankerous old guy.

"Percy," I said, "are you in a bad mood because you've got one hump, and not two?"

"HMMPH!" Percy replied.

Seems I hit the nail on the head because after that, we were pals. I miss that grumpy camel – snorts and all.

As we trundled along the 1,000-kilometre desert track, I figured out that 'Nullarbor' means 'no tree' in

Latin. The lack of trees helped me solve that brain-boggler!

However, one positively delightful thing I discovered was a glittering chunk of meteorite – yes, meteorite!

Oh, how the iron shimmered in that beating hot sun! I uncovered it while stopping for a glass of lemonade in Premier Downs. There, in the lonely Outback, meteorites have landed.

Even Percy would agree that finding a space rock on the Nullarbor Plain was an out-of-this-world experience!

Meteorite!

Flint read Ivy's diary entry to his mum.

"Space rocks!" Pam replied, nodding sagely. "Do you know what type of meteorites they are?"

"No, but the trusty rock encyclopedia might help," Flint replied, burying his nose in the book. He studied this paragraph:

There are three basic types of meteorite: irons, composed mostly of metallic iron and varying amounts of nickel; stony-irons, composed of a mixture of iron and silicon-based minerals; and stony meteorites, which are further classified into partly melted chondrites and melted achondrites.

Flint flipped through the pages and examined the photographs. He figured out that one of Ivy's rocks was a stony meteorite. With a grainy texture, it looked like a crouton that bobbed in soup or a Caesar salad!

The next silver rock was an iron meteorite. Flint wondered if it was the meteorite Ivy had

found at Premier Downs, in the Australian Outback. He gazed at the strange markings that covered it and showed Pam.

"Looks like a microchip, doesn't it?" he chuckled.

"Ah, yes, the Widmanstätten pattern," Pam replied. "It happens when iron and nickel crystals merge and slowly cool."

As Pam explained the properties of meteorites, Flint felt a rush of pride.

"You know a lot about geology, don't you, Mum?"

Pam chuckled and pointed at the third rock.

"Tell me, Flint," she said. "Is that a stony-iron meteorite to complete the collection?"

Flint raised the rock towards the light.

"I think there's been a mix-up. It's almost translucent, like glass," he replied, shaking his head.

Pam smiled. She leaned over the desk and opened a section of the book marked 'Tektites'. Flint read it out loud:

When a large meteorite hits the Earth, the rock that is hit is sometimes melted and thrown in the air, and then cools quickly to form glass.

"Yes, the meteorite impact transforms existing rocks on Earth into tektites," Pam explained.

Flint wrote three new labels for the rocks: 'Iron meteorite', 'Stony meteorite' and 'Tektite'.

Then he grasped the fourth rock. It did not fit in with the two meteorites or the tektite. It looked just like the other peculiar rock left over from 'The Ladies'!

Frowning, Flint uttered a famous space mission quote.

"Houston, we have a problem."

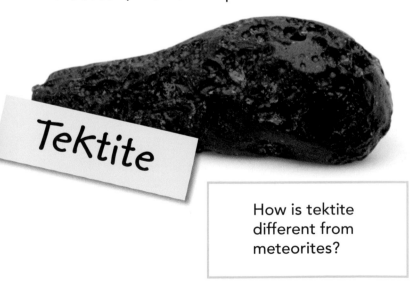

Tektite

How is tektite different from meteorites?

The Great Beyond: Is There Life Out There?

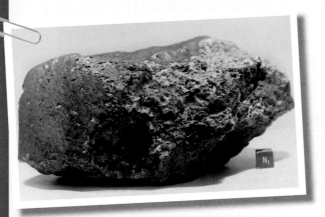

Name: meteorite Alan Hills 84001 (ALH84001)

Age: approximately 4.5 billion years old

Size: 9 cm (3½ in.) across

Date found: 27 December, 1984

Location found: Alan Hills Ice Field, Antarctica

Introduction:
Found on an annual Antarctic expedition in 1984, meteorite ALH84001 has divided the opinions of scientists and caused many to believe that there really could have been life on Mars.

Background:
The meteorite displayed small pockets of gas that matched the atmosphere of Mars perfectly. Scientists found rod-shaped tubules within the meteorite that some took to be the fossils of bacteria that had been living on the Red Planet. This would mean there had been life on Mars. Others believed that these tubules were merely the product of minerals forming at high temperature and so did not support this theory.

Conclusion:
The meteorite is currently being preserved for study at the Johnson Space Centre in Houston, Texas, USA. Scientists have still not reached a definite conclusion on whether the meteorite is evidence of life on Mars.

Question:
Do you believe there could be life on Mars?

A Mineral Mystery

Solving a mineral mystery is never easy, but gathering clues about a mineral's physical properties can help. See if you can match each set of clues to its mineral suspect.

THE SUSPECTS

ORPIMENT

HEMATITE

BARYTE

THE CLUES

EXHIBIT A

habit: has table-like or four-sided crystals
lustre: glass-like, honey-like or pearly
hardness: 3–3½
streak: white

EXHIBIT B

habit: has grape-like shapes or table-like crystals
lustre: metallic to dull
hardness: 5–6
streak: cherry-red or red-brown

DATA

habit – a mineral's general shape
lustre – how shiny a mineral is
hardness – how easily a mineral scratches;
it is measured on a scale from 1 (least hard)
to 10 (hardest) called the Mohs Scale
streak – the colour of the powder left behind
after a mineral is dragged across a rough tile

GOLD

EXHIBIT C

habit: 8-sided, 12-sided,
or tree-like crystals
lustre: metallic
hardness: 2½–3
streak: golden-yellow

EXHIBIT D

habit: no definable shape or
has many leaf-like crystals
lustre: greasy or honey-like
hardness: 1½–2
streak: pale yellow

ANSWERS: **A.** baryte; **B.** hematite; **C.** gold; **D.** orpiment

53

ENCYCLOPEDIA

Popular topics Quizzes Galleries Lists

Crystals

Article Websites Bibliography Related content

A **crystal** is a solid chemical with a regular, geometrical shape. Crystals typically have smooth, flat faces that meet in sharp edges. They often look shiny or glassy. They form amazing shapes because their atoms and molecules are bonded together in an orderly, regular, repeated pattern. Crystals aren't just flashy gems. Everyday things, such as sugar and salt, are also crystals.

All minerals are made of crystals. This is shown on the outside of the mineral as flat faces arranged in geometric forms. In many rocks, the crystals are too small to see, even with a powerful microscope, but they are there by the thousand. In rare cases, crystals may grow as large as telephone poles.

Twin crystals

Occasionally, crystals may develop in such a way that two (or sometimes more) individual crystals appear to cross each other in a symmetrical manner. Related crystals like this are known as '**twin crystals**'.

GEOLOGICA

Crystal symmetry

Crystals can be grouped into seven systems, according to symmetry: **cubic**, **monoclinic**, **triclinic**, **trigonal**, **hexagonal**, **orthorhombic** and **tetragonal**. This is seen in certain regular features of the crystal. For example, for every face, there may be another on the opposite side of the crystal that is similar. However, in most mineral specimens, it may be difficult to determine the symmetry because crystals form gradually and do not have well-developed faces.

Gallery

Tetragonal Cubic Trigonal Hexagonal

Triclinic Orthorhombic Monoclinic

● ● ● ●

CHAPTER 4

DISAPPEARING ACT

The next morning, Flint arrived at the geology department to find a sign taped to his seat: 'F. WELLES: ROCK DETECTIVE. Not the new assistant!'

Flint chuckled to himself and got to work. He grouped five of Ivy's rocks together. They were all labelled 'Disappearing Act'.

"You call yourselves a disappearing act?" he muttered in his best movie detective voice. "You wise guys ain't going nowhere!"

"Hardened criminals, eh?" Pam quipped. "Rock-hardened criminals."

Flint snickered and began taking notes.

Lavender rock: light-purple with white specks. Sparkly!

Dark-green rock: bluish bits; fine coat of white powder. Hands feel greasy.

Black rock: shiny; sooty marks left on fingers.

White rock: crumbly.

Grey rock: globby! Grey! Dreary! Again!

Flint flipped through a reference book and frowned. His fingers were leaving smudges everywhere. The rocks seemed to be disintegrating.

"WAAAAAATCHOOOOOOOOOOOOO!"

Snot shot out of Flint's nose like a revolting rocket! With one hand clamped over his face, Flint dropped his book and fled. Thank goodness only his mum saw!

After expelling tons of goo from his nose, Flint skulked back into the office. He had an enormous roll of toilet paper jammed under his jumper.

The first time Flint had experienced that sort of snot explosion, he was solving maths problems on an old blackboard. Flint discovered he was allergic to chalk dust in front of his entire, horrified class.

"Mum," he gasped, "where does chalk come from?"

"Dead shellfish!" Pam grinned. "Well, the shells from tiny sea creatures form a particular type of limestone that we call chalk."

"Limestone?" Flint pondered.

Was the white crumbly rock the cause of his problems? Was it chalk?

Flint glanced down at the desk.

His eyes opened as wide as a bug's.

When he fled the room, he had dropped the reference book on the rocks… the 'Disappearing Act'!

Sure enough, when Flint lifted the book, only one rock remained. Everything else had turned to dust!

"WAAAAAATCHOOOOOOOOOOOOO!" Flint sneezed again.

The dust soared off his desk and onto Pam's keyboard.

"Seems those horrible sandstorms really did follow us," Pam muttered, squinting at the gritty mess.

Flint shook his head, dismayed.

"Never mind, detective," Pam continued, giving Flint a sympathetic look. "Those rocks were a soft bunch. Not worth much, either."

"Ivy Singh hid those rocks deep in the Amazon jungle for decades," Flint replied in a quiet voice. "Somehow, I destroyed them in one goofy sneeze."

Pam chuckled, and gave her son a hug.

"No, Flint. You destroyed those rocks in two goofy sneezes."

She took the roll of toilet paper and swiftly wiped the evidence from her desk before tossing it in the rubbish bin.

Flint gasped. Shouldn't they save the dust? Sue would be furious!

"Don't worry too much, honey!" Pam quipped, noticing her son's anguished look. "The rocks were common. Any clue what they were?"

Flint's eyes watered and his nose tingled.

"Was the white rock chalk?" he ventured, holding back a sneeze.

"Bingo!" Pam shouted, slamming him a high five. "How about a quiz?"

If there was one thing Flint Welles loved, it was quizzes!

According to Pam, why should Flint not worry about destroying the 'Disappearing Act' collection?

"What do you draw with in art class?" Pam asked.

Flint fired his answers: "Crayon! Pencil!"

"Yes! Pencil lead is actually graphite." Pam explained. "That is what the shiny black rock was."

"What do babies smell like?" she quizzed.

Flint shuddered at the thought.

"All sorts of horrible stuff," he muttered. "Oh, and baby powder!"

"That's right! Talcum powder. The greenish rock was talc," Pam grinned, enjoying herself.

"How about chips, Flint?" she asked. "What do you put on chips?"

"Ketchup?" Flint wondered. "Salt!"

"Eureka!" Pam exclaimed. "The purple-white rock was rock salt, also known as halite."

"They really were quite fragile specimens, weren't they, Mum?" Flint remarked.

"Ivy got her disappearing act, that's for sure!" Pam replied. Her gaze fell on the only rock remaining in the group. It was grey, globby and seemingly strong – just like the other two rocks that had been left over.

"Puzzling," Pam said simply.

Flint nodded.

He opened Ivy's notebook to see if he could find out any more about the 'Disappearing Act'. One word leapt from the page: 'chalk'.

He tried not to sneeze.

Wednesday, 15 May, 1929

Hello!

Ra and I went on a swoop over the White Cliffs of Dover. I waved at the new first-class ferry, the *S.S. Canterbury*, on her maiden voyage to Calais, France. Some passengers stayed on the deck, but most would have been hobnobbing in the luxurious palm court.

I stopped by the cliffs and gobbled up a sardine sandwich. While I was there, I chipped off a chunk of chalk for Miss Patterson, my favourite schoolteacher, and took some for my own 'disappearing' collection. You never know – it might come in handy for hopscotch.

Miss Patterson was a fabulous teacher, and always encouraged me to follow my dreams. She once said, "Only the sky's the limit with you, Ivy!"

How true!

Flint closed Ivy's notebook and gazed out of the window. To his delight, an old-fashioned biplane was doing loops high in the clouds.

In one blink, the biplane was gone! In its place was a modern airliner making a steady climb after takeoff.

Ivy Singh's adventures long ago really were firing Flint's imagination.

Adamantine Auction House

Welcome to the Adamantine Auction House. We specialise in items made from the finest minerals. We have some very rare and exciting items on offer today, each of which is made from a different mineral. Get your bidding cards ready!

Lot 1.

Antique mercury thermometer

This large, vintage thermometer will add a touch of elegance to any country retreat. The mercury (metallic liquid) inside accurately measures the temperature by increasing and decreasing in size with even the slightest change in conditions.

Quartz watch

This is the perfect timepiece for those who appreciate quality workmanship. Its mechanism is regulated by tiny quartz crystals, which vibrate more than 30,000 times each second, making it a precise timekeeper.

Lot 2.

White-marble horse statue
This majestic piece dates back to 490BCE. The statue was rescued from the Acropolis in Athens and is made from white marble. The marble has a warm, creamy glow because the crystals inside it reflect light. The statue would be the perfect addition to any home.

Lot 3.

Lot 4.

Spanish gold coins
These 16th-century coins are made of 22-carat gold and were salvaged from the famous *Nuestra Señora de Atocha* (Our Lady of Atocha) ship, which sank off the coast of Florida in 1622. Gold was often used to make coins because it was flexible and could be pressed into different shapes.

Rock Stars!

Throughout the world, there are natural rock formations that have become famous for their sizes, colours or cultural meanings. Here are five of the most remarkable rocks on the planet and their locations.

THE GRAND CANYON
Location: Arizona, USA
Types of rock: sandstone and limestone
Fact: this enormous gorge was carved by the Colorado River during the last five or six million years.

SHIPROCK
Location: New Mexico, USA
Type of rock: volcanic breccia
Fact: it was formed by an explosive volcanic eruption around 30 million years ago.

THE GIANT'S CAUSEWAY
Location: County Antrim, Northern Ireland
Type of rock: basalt
Fact: it is made up of approximately 40,000 interlocking hexagonal columns.

ULURU, OR AYERS ROCK
Location: Northern Territory, Australia
Type of rock: sandstone
Fact: iron-rich minerals on its surface produce its rusty-orange colour.

WHITE CLIFFS OF DOVER
Location: Kent, England
Type of rock: chalk
Fact: the cliffs stay white because they are constantly being eroded by wind and rain, so the new layers underneath the surface become exposed.

CHAPTER 5

ODDBALLS AND WEIRDOES

The next day, Flint and his best friend Archie visited a skate park. Flint had wanted a break from rock-sleuthing, but he could not focus on his kickflips.

"Archie," he said, "do you want to work at Mum's office?"

"Working during the summer holidays?" Archie groaned. "Do you have rocks in your head?"

"It's more like rocks on the mind!" Flint quipped. "Can we go to the museum now?"

The rocks on Flint's mind were the three glob-shaped ones. They obviously belonged together. Why did Ivy try to mix them up with her peculiar labels?

Back at the museum, Pam was surprised to see the boys.

"Rocks on his mind!" Archie explained, pointing at Flint.

Pam grinned. She had rocks on her mind all the time!

Flint showed Archie the rocks he had identified so far. Then he revealed the three mystery glob-shaped rocks.

Archie grasped each rock. He examined their pasty sheen, and compared their weight and size.

"I know what they are," he said calmly.

"What?" gasped Flint and Pam.

"Very ugly!" Archie crowed, flashing a triumphant grin.

"With jokes like that," Flint said, "you're sure to feel right at home in the geology department!"

"Meteorites?" Archie asked, squinting at Flint's tiny labels. "When did you find meteorites?"

"I didn't!" Flint chuckled. "They belong to a friend of mine."

He handed over Ivy's notebook. "You should get to know her."

Flint removed some more of the rocks from the tattered box. They were marked 'Oddballs and Weirdoes'.

Mysteriously, one was wrapped in brown paper.

He spied a fourth glob-shaped rock among them and set it aside. Ivy wasn't going to fool him this time.

The first rock to catch Flint's eye was golden yellow and clear, like glass. Suspended inside it was a dead mosquito. It looked as though it was stuck in honey!

"Amber!" exclaimed Archie, looking up from the notebook. "My sister has a necklace just like it."

Flint remembered Amber's necklace. It contained a spider, also frozen in time.

"Yes, but what type of rock is it?"
Flint replied.

"Amber!" Archie repeated, exasperated.
"My sister *Amber* has an *amber* necklace."

"Amber isn't a rock," Pam explained.
"It's fossilised resin – ancient tree sap."

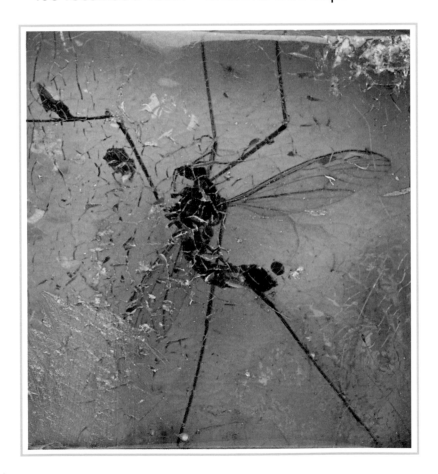

Flint inspected the amber. "Tree sap is an odd thing to keep in a rock collection," he observed.

"Amber is an organic gem," Pam replied. "It fits in with coral, shell and pearls."

Flint and Archie nodded. They examined the other 'Oddballs and Weirdoes'.

One rock was pale grey, and speckled with crater-like holes. Flint cradled the rock in his palm. It was exceptionally light.

"If I hadn't read up about meteorites," he said, "I'd think this was a moon rock."

"I know what it is," Archie admitted, with a sheepish look. "Amber gave me a pedicure once. You can use that rock to smooth your feet."

Pam handed Archie the encyclopedia.

"You got it, Archie," she said. "Now see if you can find out its name. Look up igneous rocks – volcanoes."

As Archie browsed through the encyclopedia, Flint opened the small, brown-paper package. Inside was something light brown and furry.

"DEAD RAT!" he shrieked, throwing it across the room.

Pam leapt to her feet, and collected the 'corpse'.

"It's not a dead rat!" she laughed.

"What is it?" Flint insisted. "Is it a dead mouse?"

"A dead hamster?" Archie chipped in.

"It's not a dead anything!" Pam replied. "This furry bundle is also an igneous rock – volcanic glass."

Archie grinned over the encyclopedia. "I've found it! It's called Pele's hair, spun from a fountain of lava!" He flipped to another page. "And the rock I rubbed on my feet is pumice."

Flint felt a little miffed. When did Archie become a rock expert? He was stealing his thunder!

"You found those with lightning speed," Flint muttered.

"A-ha!" shouted Pam. "Lightning. There's your clue for the last rock in this collection." She held up what looked like a fat tube of pasta covered in sand.

"What could it be?" she pressed.

"Oh, I don't know," Flint yawned, suddenly tired. "Sandy lightning?"

"Lucky guess!" Pam replied. "This is fulgurite. It forms when lightning strikes sand."

Archie was now holding Ivy's diary. He started reading in a haughty voice. Flint couldn't help but laugh!

Thursday, 12 December, 1929

Aloha!

For the love of lava, Hawaii has five active volcanoes! I flew *Ra* over Mt. Kilauea. It bubbled like a pot of tomato soup! It was not the spot to parachute jump.

Hawaiians call their volcano goddess 'Pele'. I nabbed some of Pele's hair! It's not real hair, of course, but glass threads spun from a volcano.

There are so many marvellous myths about rocks and gems! Reminds me of the old Greek legend in which amber is the tears of the god Helios's daughters.

Oh! The hula truly is as wiggly as a snake! I was hula-ing in Honolulu, when I stubbed my toe on fulgurite. Ouch! There must have been a big storm.

What else? Pumice – also from volcanoes – is dreamy on a dancer's feet. It keeps the old hooves smooth as silk.

Archie closed the diary and spoke in his normal voice.

"Can I come back to the museum tomorrow?" he asked.

Flint decided it was silly to be jealous of Archie's detective work.

"Congratulations!" he replied, with a mischievous smirk. "You'll be my new assistant!"

Amazing Amber

Amber is known as an organic gem. It is not made from minerals but from a plant. Coniferous, or evergreen, trees release a sticky substance called resin when their bark has been punctured. The resin oozes out of the tree and covers the damaged area of the bark. This hardens as it dries. Over millions of years, the resin becomes fossilised to form amber.

Preserved pests

Insects and spiders often become trapped in tree resin. As the resin dries and fossilises, the dead creatures are preserved in the dried amber. Scientists have found amber with creatures inside dating from 40–60 million years ago.

Electrifying elements

The word for 'electricity' comes from the Greek name for amber – electrum. Ancient Greek scientists noticed that amber had an electric charge when rubbed. This charge is called static.

Golden Gems

Amber is a popular gem to be used for jewellery because of its golden, orange colour.

The Amber Room in Catherine Palace, Russia
Made in 1711, the amber wall panels mysteriously went missing in World War II. The room was rebuilt in 2003.

PELE,
THE FIRE GODDESS

Many rocks and minerals are said to have mythological origins. The Hawaiian fire and volcano goddess, Pele, has given her name to two minerals – Pele's hair and Pele's tears. Both are igneous rocks. There are countless stories about Pele. Here is one of them.

Pele was descended from the supreme beings Papa, or Earth Mother, and Wakea, or Sky Father. She is said to be responsible for shaping the islands of Hawaii.

Pursued by her angry sister Na-maka-o-kaha'i, a sea goddess, Pele left her home and became one of the first travellers to Hawaii. She first landed on the island of Kauai. She tried to dig a pit for her home, but every time she dug her stick into the ground to make one, her sister flooded the pit with water and put out Pele's fire.

Pele continued to move down the chain of islands, and finally landed on the Big Island of Hawaii, at Mauna Loa, one of the largest volcanoes on Earth. This mountain was too high, and Na-maka-o-kaha'i could not flood it. Pele had finally found her home. Here, she welcomed her brothers Ka-moho-ali'i, god of sharks; Kane-hekili, who appears as thunder; Kapoho-i-kahi-ola, who appears as explosions; Ke-ua-a-kepo, who appears as showers of fire; and Ke-o-ahi-kama-kaua, who appears as spears of lava.

To this day, Pele is unpredictable and continues to shape the Hawaiian landscape. When she stamps her feet, she causes earthquakes, and when she digs with her magic stick, she causes eruptions and sends streams of lava down the mountainside of the Kilauea volcano.

CHAPTER 6

NOW YOU SEE IT

The following day, Archie arrived at the museum to find Flint crouched behind an enormous stack of geology books.

"Now You See It?" Archie yawned, eyeing Ivy's cryptic labels. "All I see is four plain old rocks!"

"Don't fall into that trap, Arch!" Flint chuckled. "I have learnt there is nothing ordinary about Ivy's rock collection."

He held up a creamy-white rock with a rough, uneven surface.

"Mum, I am pretty sure this specimen is calcite," he said. "It matches the descriptions in these books. What do you think?"

"I think you're right!" Pam grinned, looking up from her computer. "Calcite is a very common mineral. It forms a variety of spectacular crystals. That shape is known as stalactitic because it looks like stalactites."

Archie pointed at the three rocks remaining. "What about these? They don't look that special."

"It depends on how you look at them!" Pam said mysteriously. "Why don't you search for clues in Ivy's notebook? I'm going to get a lamp."

"Lamp?" Flint repeated. "The room is glowing with sunshine!"

"Glowing?" Archie echoed, scratching his chin. "That reminds me of something I read earlier."

He picked up Ivy's notebook and leafed through the pages.

"A-ha!" he bellowed, passing the book to Flint. "This sheds some light!"

Wednesday, 1 February, 1928

Isn't New Zealand fun? I came here to dance, wowed the crowd and then flew *Ra* all over the North Island. I skied on a volcano (Ruapehu), ogled bubbling mud pools in Rotorua and paddled a canoe into the Waitomo cave.

Spooky?

You'd think so!

Deep in that cave, I saw quite a show. The cave walls were twinkling, just like the stars in the night sky.

"Eureka!" I yelped. "More phosphorescent rocks for my wonderful collection. Now you see it; now you don't."

My tour guide Tama set me straight. The glowing walls weren't phosphorescent rocks; the glowing walls were glow-worms!

Stunning!

"What do you say, Flint?" Archie grinned. "Do you think these rocks glow in the dark?"

"Well, I can't see any light bulbs," Flint joked, "and there don't seem to be any batteries, either."

He squinted at the sunlight streaming through the office windows.

"If these rocks glow, we need to find some dark place," he added seriously. "Maybe the museum has a basement."

The two boys carefully gathered the 'Now You See It' rocks and wandered into the museum corridor.

"This will do the trick!" Archie exclaimed, pointing at a small sign on a door that said 'BROOM CUPBOARD'.

As he flung
the door
open, two
brooms,
a mop and
a trio of metal
buckets spilled out
of the cupboard and
clanged into the corridor.

"What's going on here?"
demanded a stern voice.

Flint and Archie spun around. Pam
stood there chuckling. She had a lamp
in her hand.

"We've found somewhere to look at these
rocks," Flint explained. "We think they might
glow in the dark!"

"Good thing I've got this ultraviolet lamp," Pam replied, grinning. "It's battery-powered, too!"

Flint, Archie and Pam crammed into the broom cupboard and shut the door. CLICK.

When Pam turned on the lamp, they were surrounded by a dim, purple glow. Suddenly, everyone's teeth were super white!

"Creepy!" Archie exclaimed, chattering his teeth. "It looks like Halloween in here."

"Really?" asked Pam. "I'd say it looks more like Christmas."

Everyone gasped.

The rocks that Archie had described as 'not that special' were now glowing festive shades of green, blue and pink.

"Now you see it!" marvelled Flint.

"The scarlet-pink rock is calcite," Pam explained. "The bright-green rock is adamite. That yellow-

and-blue rock with pink specks is willemite. And that pale-pink rock is scheelite."

As they clambered out of the closet, three of the rocks seemed to 'turn off'. Astoundingly, the willemite continued to shine gently.

"Why is it still blue?" Flint asked.

"Excited atoms," Pam explained. "Basically, the atoms inside these minerals take in light, get energised, and then appear to glow. This is called fluorescence. The willemite is phosphorescent. It has an afterglow when the UV light is removed."

Back in Pam's office, Flint and Archie labelled the 'Now You See It' collection.

"These rocks are anything but ordinary!" Flint exclaimed. "Fluorescent! Phosphorescent! It's almost as if they are in disguise."

"Yes, yes, you were right," Archie groaned. "I want a collection like this myself," he continued. "With UV lighting, my bedroom would look like a disco."

"Wait a minute – I've seen your room," Flint replied, teasingly. "It would look like a toxic waste dump."

"That's it!" Archie shouted, gleefully. "I'd stick a warning on the door: 'Biohazard. Radioactive material. Enter at your own risk!'"

"It sounds like a wonderful way to start a collection, Arch," Pam laughed. "Always learn about your rocks. Some popular rocks, like autunite, are truly radioactive. They must be handled with care."

Flint handed the box full of labelled rocks to his mum.

"Mission accomplished!" he grinned. "We've successfully identified Ivy's rocks."

"Not quite," Archie said flatly. "Remember these guys?" He pointed at the lonely line-up of pasty grey glob-rocks.

The three rock detectives frowned, deep in thought.

What on Earth could they be?

Why does Archie need to learn about rocks before he starts his rock collection?

The structure of Minerals

Minerals are made up of elements. Elements are made up of tiny particles called atoms. These atoms can stick together in different ways to form different minerals.

The atom

The atom of each element is unique to that element because it has a specific number of protons. Protons are parts that have a positive electrical charge. Atoms are also made up of negatively charged parts called electrons and parts with no charge called neutrons.

Nucleus is made up of neutrons and protons.

Number of protons and electrons is the same.

Electrons orbit the nucleus.

Molecules

Atoms can bond or join up with other atoms of the same element or of a different element to form molecules.

Hydrogen atoms

Oxygen atom

These two elements combine to form water.

Allotropes

Sometimes two different sets of molecules of the same atoms can form different minerals. These are called allotropes and occur because the atoms can be bonded together in different ways. The atoms of the element carbon, for example, can bond to form diamonds or graphite (pencil lead).

Atoms in diamonds are strongly bonded to four others to form a stiff, compact structure.

Carbon atoms in graphite are closely linked to three others arranged in widely spaced layers that are only weakly bonded together.

ULTRAVIOLET DISCO

Fluorescence or phosphorescence?
Many minerals fluoresce. This means that they glow when under a UV lamp, but they stop glowing once the lamp is turned off. Other minerals are phosphorescent. This means that they continue to glow after the UV lamp has been turned off because they release their light at a slower rate.

Get your atoms excited at the Ultraviolet Disco!

Come and glow the night away to some rocking tunes and stone-cold beats. The Ultraviolet Disco has been named the mineral hangout of the year and is guaranteed to get all your atoms jumping!

Calcite will often fluoresce red or blue. There are more than 300 different types of calcite. It is found in most places on earth and is often used in cement.
Hardness: 3

Calcite

Adamite fluoresces bright green. It forms in great quantities in the Ojuela Mine in Mexico, among other places on Earth.
Hardness: 3.5

Adamite

Willemite

Willemite often fluoresces green and was used in the tubes of early televisions.
Hardness: 5.5

What's happening?

The atoms of these rocks absorb energy from the ultraviolet light and become 'excited'. They stay in this excited state for no more than tiny fractions of a second; then, as they move back into their 'unexcited' state, termed their 'ground' state, the energy they absorbed is released as fluorescent light.

RADIOACTIVITY

Some elements are naturally radioactive. Radioactivity at a low level is a natural part of the world around us, and is harmless. It is found in some kind of rocks and even some foods. A few rocks and minerals have higher levels: always ask an adult to help you with them.

RADIOACTIVITY DESTROYS LIVES. LOOK OUT FOR THIS SYMBOL.

META-TORBERNITE

URANINITE

AUTUNITE **CARNOTITE**

HANDLE RADIOACTIVE SPECIMENS WITH CARE.

⚠ Store potentially radioactive specimens in airtight containers in a garage or basement.

⚠ Avoid direct contact with radioactive specimens.

⚠ Never eat, drink or sleep near any radioactive specimens.

⚠ Label all radioactive specimens as radioactive.

WHAT IS RADIOACTIVITY?

Most atoms have stable nuclei – the number of neutrons and protons in the nucleus stays the same. Others, such as uranium atoms, have unequal numbers of neutrons and protons. This makes them unstable and likely to break down, or decay. When an unstable atom decays, it releases energy called radiation. In large doses, radiation is extremely dangerous to a person's health. In small doses, it can be used to fight cancer and to take x-rays.

CHAPTER 7

A STICKY SITUATION

The next morning, Archie arrived at the museum wearing goggles and a cap with fluffy earflaps.

"Are you going swimming or skiing?" Flint asked.

"Neither!" Archie announced, his eyes twinkling. "I say, dear Flinty, flying planes and collecting rocks truly is a delight! Such fun!"

Pam burst out laughing. "Archie seems to be dressed up just like Ivy – all the way down to her flying gear!"

Archie grinned. "That's right, Mrs W. If I *look* like Ivy, perhaps I can *think* like Ivy. It's an old detective's trick!"

"The likeness is uncanny!" Pam replied.

She handed Flint and Archie a stack of newspaper clippings. They reported Ivy's many adventures back in the 1920s. In each photograph, Ivy was flying, digging or dancing!

"Where did you find these?" Flint asked.

"Oh, geologists are rather good at digging things up!" Pam quipped.

Flint held up a bubble gum advertisement. It showed Ivy and *Ra* zooming over clouds of pink and green bubbles! It said,

When bubbly Ivy Singh flies the skies, she chews Pilot Gum. Available in spearmint and strawberry.

"Wow, that's the Singh family gum business!" he exclaimed.

Flint turned his attention to the newspaper headlines. He read them out loud in a jaunty old-fashioned reporter voice:

Ivy Singh Crosses English Channel; Flies Back Again for More Croissants!

THE SINGH'S THE THING!

Ivy Digs Up Dinosaur Thigh Bone! Performs with it at Royal Albert Hall!

OUR GIRL IVY BEWILDERS BANDITS AND SAVES THE DAY!

"Bewilders bandits?" Pam and Archie repeated in unison.

"Seems we're not the first people Ivy has puzzled!" Flint laughed. He read the article out loud:

Cape Town, South Africa, 18 May – There's no stopping Ivy Singh! While rafting around the Cape of Good Hope last week, the young adventuress met a gang of bandits hiding in a cave. She soon realised they were holding valuable goods – dazzling Indian diamonds! Ivy charmed the starstruck bandits and became friends. Then, with methods only known to Ivy, she removed the diamonds over a number of days. When the bandits were eventually arrested, they were astonished!

"I can't reveal all my secrets," Ivy told our reporter, "but it was quite a sticky situation!"

"Quite a sticky situation," Flint repeated. It sounded like one of Ivy's clues.

He frowned at the five glob-rocks sitting on his desk. They were as pasty and drab as they had always been. What could they be? He had read all the reference books, and they didn't seem to be like any other rock. Pam was an expert on rocks, and even she was stumped!

Suddenly, it dawned on him. The glob-rocks weren't really rocks at all. They were something that he had seen countless times jammed under tables at school – something that could create quite a sticky situation.

"By gum, I've got it!" he shouted. "Mum, pass me your strongest chisel!"

Pam dug a chisel out of her drawer and handed it to Flint.

He started gouging and carving at the 'rock'. With the force of the chisel, the grey substance splintered into shards and slivers.

There, at the core, was an enormous glittering pink diamond.

"Ivy rescued the smuggled diamonds by hiding them in bubble gum!" he declared triumphantly.

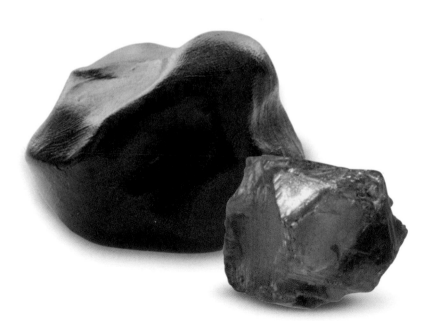

Pam and Archie gasped at the phenomenal jewel. Without another word, they chiselled at the four remaining glob-rocks.

Flint's hunch was right. Inside each glob-rock was an enormous pink diamond!

"Never judge a book by its cover," mumbled Archie in disbelief. "Speaking of which, why didn't Ivy write about these diamonds in her notebook?"

Flint's face lit up again.

"Maybe Ivy did write about the diamonds," he said mysteriously.

"You mean she wrote in code?" Archie replied, confused.

The door burst open. It was Sue.

"Have my young detectives cracked the case yet?" she asked, chirpily.

Pam pointed at the five pink diamonds dazzling on the desk.

Sue's eyes bulged. She was lost for words!

"Goodness gracious!" she finally uttered. "Where on Earth are they from?"

Flint rifled through Ivy's notebook. He showed two blank pages to the group.

"Sue, I think the answer is written in invisible ink," he announced. "Follow me to the broom cupboard! Mum, please bring the UV lamp!"

Once everyone was in the cupboard, Pam turned on the lamp. CLICK!

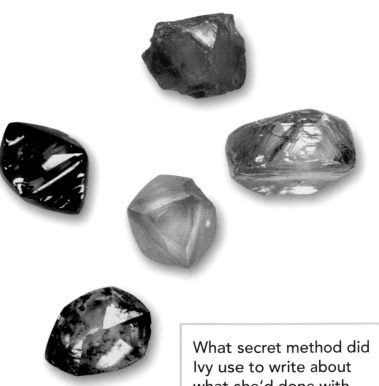

What secret method did Ivy use to write about what she'd done with the diamonds?

Like magic, Ivy's words danced across the pages.

Saturday, 19 May, 1928

After a terrific storm, I bumped into smugglers hiding out in a cave! One smuggler, Wally, recognised me. He knew I was fond of rocks, so he showed me the loot! Diamonds!

Wally bragged that five of the diamonds – enormous pink ones – once belonged to a duchess. Wally, that silly goose, was confused! I'd seen those sparklers before. My old friend Winnie is the rightful owner. Winnie is no duchess, but she owns a fancy chocolate company called Dutch's! Scrumptious!

Anyway, I had to smuggle those diamonds from the smugglers.

Thank goodness I always carry a big box of Pilot Gum.

The authorities were thrilled with the haul. Winnie, however, didn't want her diamonds back! She said they attract robbers!

Winnie's right – diamonds *do* attract robbers. I'll stash them in the tree house for now.

I know! I'll bamboozle would-be thieves by hiding them with ordinary rocks! If only I could make them invisible like this ink. Some day, I'll donate the diamonds to a museum.

Diamonds!

Flint, Pam, Archie and Sue spilled out of the cupboard and into the corridor.

"Good job, Flint!" Sue cheered. "The diamonds are finally safe in a museum."

"Diamonds do attract robbers," Pam cautioned. "We might need more security guards."

"Or bubble gum!" Flint quipped.

Pam hugged her son. "Without your detective work, Flint, those priceless diamonds could have been stuck in gum forever."

"Let's not forget my assistant," Flint replied, patting his best friend on the back.

Flint passed Ivy's notebook to Sue. "This belongs to the Singh family," he said. "Their great-grandmother was a remarkable person."

Sue nodded and handed Flint an envelope.

"Another mystery?" Flint groaned.

"Look inside," she chuckled. "See what you think!"

Flint had heard that one before! He nervously opened the envelope.

Inside were three plane tickets to
Mongolia. They were leaving tomorrow!

"Pack your bags, Mum and Archie!"
Flint shouted. "We're off to dig up dinosaurs
– unless we unearth something more
interesting!"

"Something more interesting?" yelped
Pam. "Now you really do have rocks on
the brain!"

DIAMOND DAZZLERS

Welcome to Heart of Gold Jewellers. Here is our gallery of the most famous diamonds in the world. Each one has been cut to perfection, and many have been owned by some of the most influential people in history.

Great Star of Africa *(530.2 carats)*
This diamond – cut from the Cullinan Diamond – is the largest cut diamond in the world. It is now on display in the Tower of London in England and mounted in Great Britain's Royal Sceptre.

Koh-i-Noor *(105.6 carats)*
Since 1304, this diamond, whose name means 'mountain of light', has been owned by many Indian and Persian rulers. The jewel became part of Britain's crown jewels in 1877. It is on display with the Great Star of Africa in the Tower of London.

Millennium Star *(203 carats)*
It took three years for experts to cut this diamond – discovered in 1990 – into its flawless pear shape. It is so perfect that jewellers still struggle to put a price on it. It is owned by diamond company De Beers.

Hope Diamond *(45.5 carats)*
Some believe that this dark-blue diamond brings misfortune to those who own or wear it. One of its owners was Marie Antoinette, who was beheaded in 1793. It can now be seen at the Smithsonian Museum of Natural History in Washington, D.C.

Write a Message in Invisible Ink

Do you have a secret message that you need to keep hidden from prying eyes? Then you need indelible invisible ink from Cloak-and-Dagger Industries! Follow the method below to make our cunning, code-cover-up ink.

Ingredients:

- lemon juice
- white paper
- paintbrush
- iron and ironing board

1

Squeeze the lemon juice out into a bowl.

2

Dip a paintbrush into the juice and use it to write your message onto the paper.

3

As the message dries, it will gradually disappear.

4

To see your message again, ask an adult to iron the paper with a hot iron. The writing will slowly turn brown and become visible.

Fact:
The science of hiding messages is called steganography.

Collecting Rocks

It's easy to find lots of amazing rocks near your home. All you need is a pair of sharp eyes and a bit of patience. Here are some tips to help you get started.

WHAT YOU WILL NEED

- bag for collecting rocks
- water
- dishwashing bowl
- detergent
- scrubbing brush
- pocket knife
- magnifying glass

WARNING!

Pocket knives can be dangerous. Only use these with adult supervision.

IMPORTANT!

To be a good rock collector, you need to follow certain safety procedures.

1 Walk slowly as you look at the ground and collect as many different types of rock as you can: hard, soft, smooth, shiny, rough, crumbly, flat and so on. Don't worry if they are dirty – you can clean them at home.

2 Clean the rocks when you get home. Brush off loose dirt, or scrape it off with a pocket knife. Then wash the rocks in warm water with a little detergent. Use a scrubbing brush to remove dirt.

3 Leave the rocks to dry, and then inspect them with a magnifying glass. Can you see individual grains or crystals? Feel the rocks carefully to see which ones are hard or crumbly.

TIP

The best places to look for rocks are on cliffs or in quarries, and along beaches, riverbeds and fields. Cliffs and quarries can be dangerous, though, so go with an adult.

Start a Collection

A collection of rocks grows better and better over time, and the best specimens can be arranged to make a spectacular display. It's important to label all your specimens and keep a careful record of everything you know about them.

WHAT YOU WILL NEED

- your specimens
- white correction fluid, or white stickers
- black, fine-point permanent marker
- index cards
- two index card files
- cardboard specimen trays, matchbox trays or egg cartons
- cotton balls or tissue paper
- magnifying glass

1 Assemble your specimens. Put a small dab of correction fluid on an unimportant side of each one and let it dry. Alternatively, use a small white sticker. Use the permanent marker to write a reference number on each mark or sticker, starting with 1.

Index cards

Magnifying glass

Correction fluid

Cotton balls

2 Fill out an index card for each specimen, writing its number at the top. Write down the type of rock and the name of the mineral or fossil (if you know them) under the number. Also write down where each specimen came from and any other interesting details. Keep the cards in number order.

3 Prepare a second index card with the name of the rock, fossil or mineral at the top and its number below. Keep these cards in alphabetical order in a separate card file. You can then look up specimens by name and number.

4 Place each specimen in a small cardboard tray, matchbox tray or egg carton. Put cotton balls or tissue paper under delicate specimens. Arrange your specimen trays in a drawer or large box to display them.

MOTHER, SON AND BEST FRIEND FIND NEW DINOSAUR!

Batz Besud – Mongolian correspondent

English boy Flint Welles, his mother Pamela Welles and his best friend Archie Stark were astonished to uncover what seems to be an unidentified dinosaur fossil during a week-long dinosaur excavation in the Gobi Desert, Mongolia. The discovery has palaeontologists really excited.

"Only in my wildest dreams could I have imagined we'd dig up a type of *Velociraptor*," Flint Welles, 12, commented. "Even then, there have only been a dozen or so *Velociraptor* fossils found. To find an entirely new dinosaur is out of this world!"

Flint's mother, Pamela Welles, 45, said she was proud of her son's diligence. "I am a geologist, and never before have I seen anyone work as hard

as my son Flint and his best friend Archie. These young men have enquiring minds and a strong work ethic, which makes me very proud."

"Watch out, world!" Archie Stark, 12, quipped. "Flint and Archie are an unstoppable force!"

Last month, Flint Welles uncovered five priceless pink Indian diamonds that once belonged to well-known chocolate heiress Winifred Price. The diamonds had been stolen earlier this century, and had lain hidden in the Amazon rainforest for decades.

ROCK BOX QUIZ

See if you can remember the answers to these questions about what you have read.

1. How old did Ivy Singh live to be?

2. How many groups of rocks does Flint have to identify?

3. What was the name of Ivy's plane?

4. What are the three types of rock?

5. Which month of the year has pearl as its gemstone?

6. What word is used to describe how shiny a mineral is?

7. True or false: all minerals are made of crystals.

8. What mineral is Flint allergic to?

9. What mineral is used to regulate watch mechanisms?

10. What is the name of the largest cut diamond in the world?

11. What is the Hawaiian volcano goddess called?

12. What happens to the 'Now You See It' rocks when the UV light is shone on them?

13. What happens when an unstable atom decays?

14. What is the name of the Singh family gum business?

15. How did Ivy hide her friend Winnie's diamonds?

Answers on page 125.

GLOSSARY

Açai
Type of black-purple berry that grows on palm trees in Central and South America.

Archaeologist
Person who studies artifacts to learn about past human life.

Biohazard
Short for 'biological hazard', a substance that comes from living things and is dangerous to a person's health.

Biplane
Type of plane that has two main wings, one above the other.

Camu camu
Type of red, cherrylike fruit from a tree that grows in the Amazon.

Charleston
Type of dance popular in the 1920s in which the knees are turned in and out.

Geology
The science that studies the features of Earth, usually through rocks.

Indelible
Unable to be erased.

Palaeontologist
Person who studies fossils to learn about how life on Earth has changed.

Salvage
To rescue or save something from a wreck.

Stalactite
Cave formation that looks like an icicle hanging down.

Translucent
Allowing light to pass through.

Tubule
Small tube.

Ultraviolet (UV) light
Type of light that is not visible; in large doses, it can be harmful to humans.

INDEX

Answers to the Rock Box Quiz:

1. 105; **2.** Five; **3.** *Ra*; **4.** Igneous, metamorphic and sedimentary; **5.** June; **6.** Lustre; **7.** True; **8.** Chalk; **9.** Quartz; **10.** Great Star of Africa; **11.** Pele; **12.** They glow; **13.** It releases energy called radiation; **14.** Pilot Gum; **15.** By covering them with gum.

Guide for Parents

DK Reads is a three-level interactive reading adventure series for children, developing the habit of reading widely for both pleasure and information. These chapter books have an exciting main narrative interspersed with a range of reading genres to suit your child's reading ability, as required by the National Curriculum. Each book is designed to develop your child's reading skills, fluency, grammar awareness, and comprehension in order to build confidence and engagement when reading.

Ready for a *Reading Alone* book

YOUR CHILD SHOULD

- be able to read independently and silently for extended periods of time.
- read aloud flexibly and fluently, in expressive phrases with the listener in mind.
- respond to what they are reading with an enquiring mind.

A VALUABLE AND SHARED READING EXPERIENCE

Supporting children when they are reading proficiently can encourage them to value reading and to view reading as an interesting, purposeful and enjoyable pastime. So here are a few tips on how to use this book with your child.

TIP 1 Reading aloud as a learning opportunity:

- if your child has already read some of the book, ask him/her to explain the earlier part briefly.
- encourage your child to read slightly slower than his/her normal silent reading speed so that the words are clear and the listener has time to absorb the information, too.

Reading aloud provides your child with practice in expressive reading and performing to a listener, as well as a chance to share his/her responses to the storyline and the information.

TIP 2 Praise, share and chat:

- encourage your child to recall specific details after each chapter.
- provide opportunities for your child to pick out interesting words and discuss what they mean.
- discuss how the author captures the reader's interest, or how effective the non-fiction layouts are.
- ask the questions provided on some pages and in the quiz. These help to develop comprehension skills and awareness of the language used.
- ask if there's anything that your child would like to discover more about.

Further information can be researched in the index of other non-fiction books or on the Internet.

A FEW ADDITIONAL TIPS

- Continue to read to your child regularly to demonstrate fluency, phrasing and expression; to find out or check information; and for sharing enjoyment.
- Encourage your child to read a range of different genres, such as newspapers, poems, review articles and instructions.
- Provide opportunities for your child to read to a variety of eager listeners, such as a sibling or a grandparent.

Series consultant **Shirley Bickler** is a longtime advocate of carefully crafted, enthralling texts for young readers. Her LIFT initiative for infant teaching was the model for the National Literacy Strategy Literacy Hour, and she is co-author of *Book Bands for Guided Reading* published by Reading Recovery based at the Institute of Education.

Have you read these other great books from DK?

Dramatic modern-day adventure as Mount Vesuvius re-awakens.

Discover what life for pilots, women and children was like during WWII.

Pulse-racing action adventure chasing twisters in Tornado Alley.

Time-travelling adventure to the Wild West caught up in fossil hunters' rivalry.

Emma adores horses. Will her wish come true at a riding camp?

Lucy follows her dream to train as a professional dancer.